T0368472

WORLDS WITHOUT LIMITS

THE ART OF RBT DESIGNS

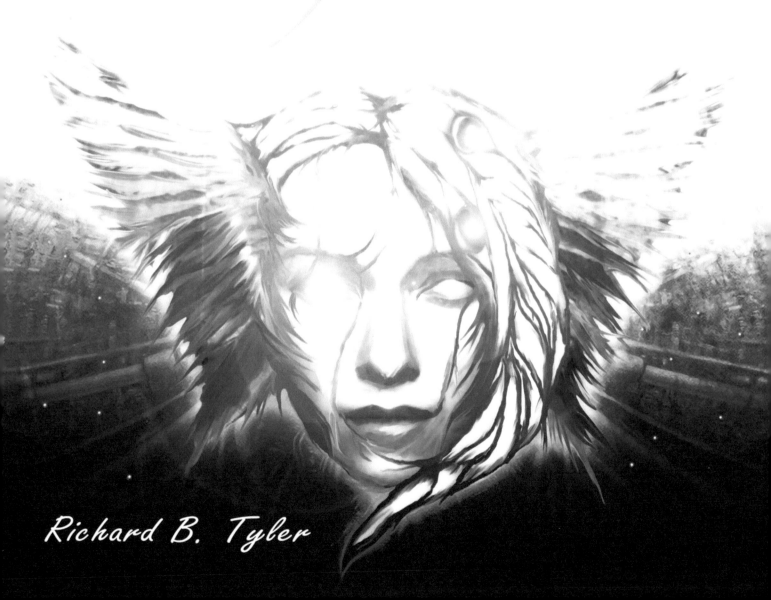

Richard B. Tyler

AuthorHouse™
1663 Liberty Drive
Bloomington, IN 47403
www.authorhouse.com
Phone: 1 (800) 839-8640

Published by AuthorHouse 5/29/2015

ISBN: 978-1-5049-1401-7 (sc)
ISBN: 978-1-5049-1402-4 (e)

Print information available on the last page.

Any people depicted in stock imagery provided by Thinkstock are models, and such images are being used for illustrative purposes only.
Certain stock imagery © Thinkstock.

This book is printed on acid-free paper.

Because of the dynamic nature of the Internet, any web addresses or links contained in this book may have changed since publication and may no longer be valid. The views expressed in this work are solely those of the author and do not necessarily reflect the views of the publisher, and the publisher hereby disclaims any responsibility for them.

WORLDS WITHOUT LIMITS

THE ART OF RBT DESIGNS

Richard B. Tyler

INTRODUCTION

It has been three years since I have published my last art book. "World's Without Limits" contains detailed collection of science fiction and fantasy illustrations which I have completed between 2013 and 2014. The artwork in this book is appropriate for people of all ages and is presented in various formats like watercolor, acrylic, digital and mixed media.

A majority of the illustrations I have provided in this book are concepts which I was inspired to create randomly. A few of my illustrations such as "Auguste" (page 28) are part of a larger story. I intend to create books for the illustrations which have a back story, and use the illustrations which do not contain back stories for other projects.

Swiss surrealist airbrush painter H. R. Giger who is known for his biomechanical art style and his creature design for 1979's horror/sci-fi film "Alien" was a significant influence to me when I created this book. Japanese filmmaker and character designer Keita Amemiya who is known for several movies and TV shows in Japan, including the 1991 sci-fi film "Zeiram" and his 2005 TV series "Garo" was another influence for my illustrations. The cartoons and movies of my youth reflected many unique styles which encouraged me to find my own style.

Explore new worlds, new creatures, and new possibilities. Enter into a world without limits.

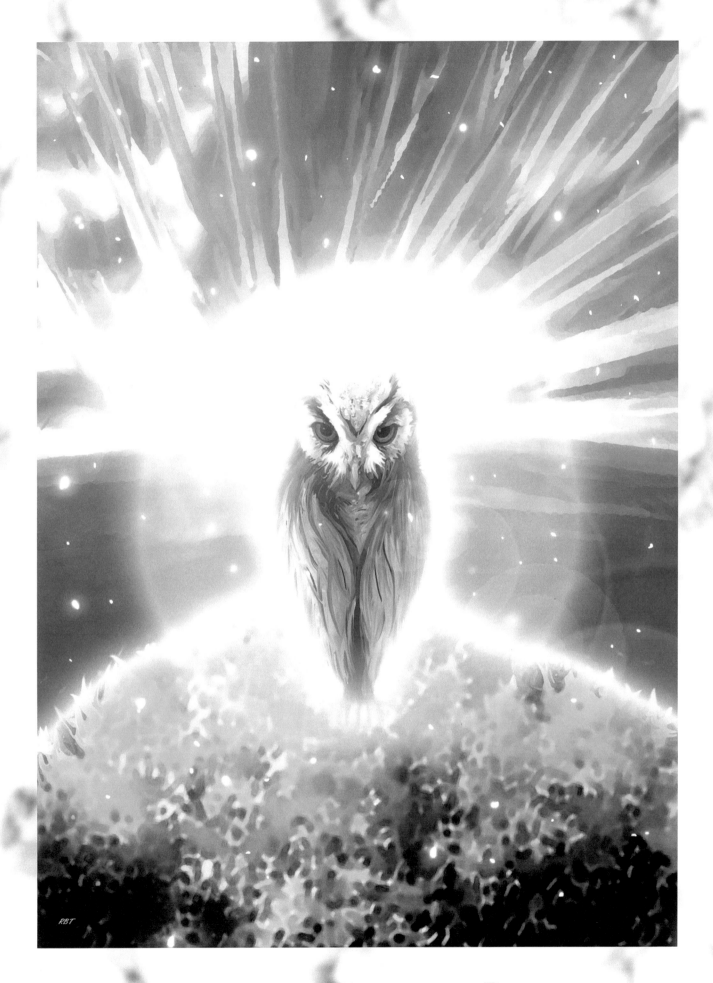

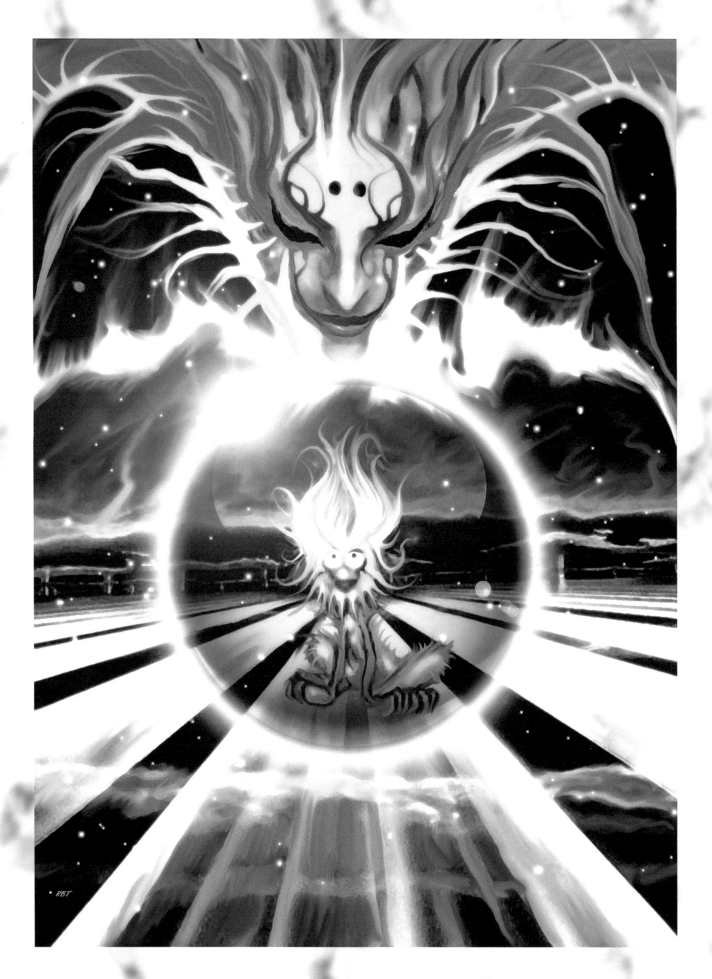

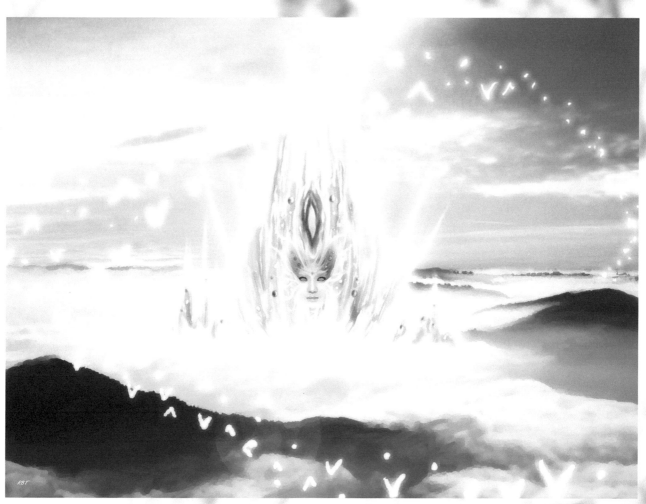

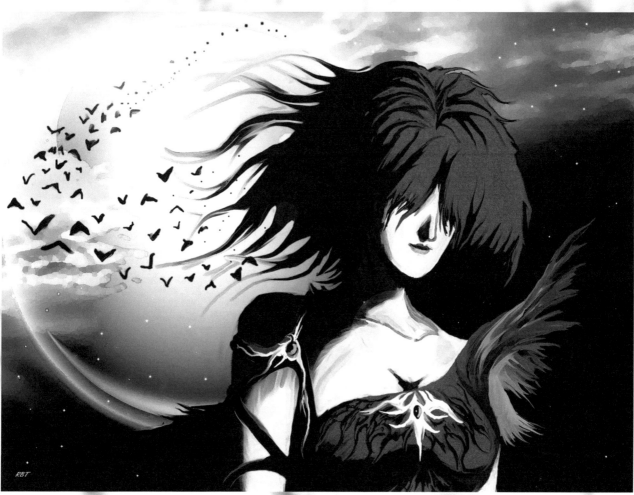

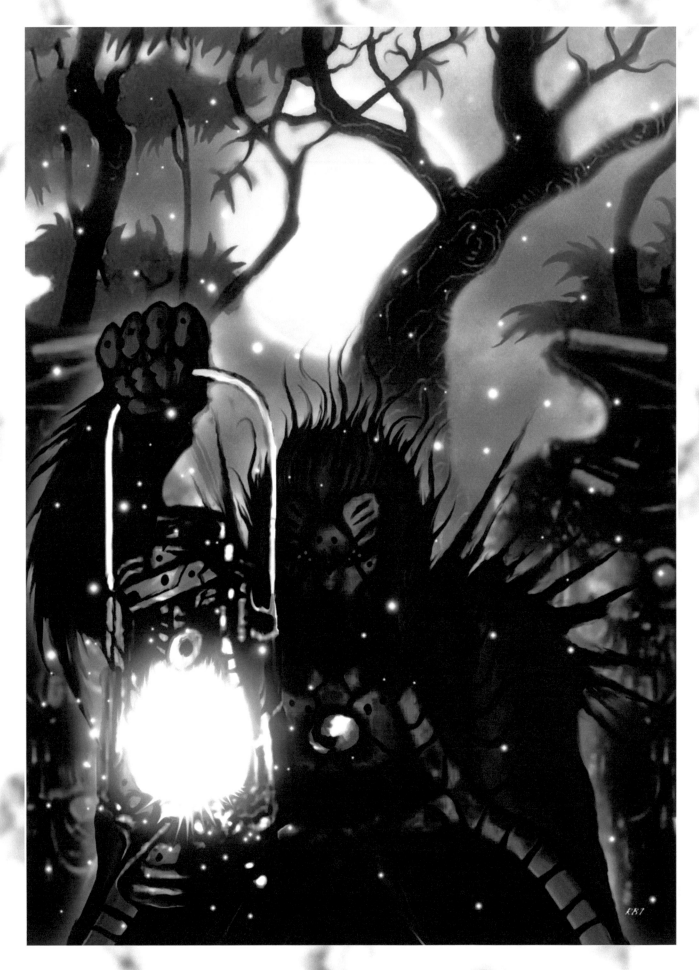

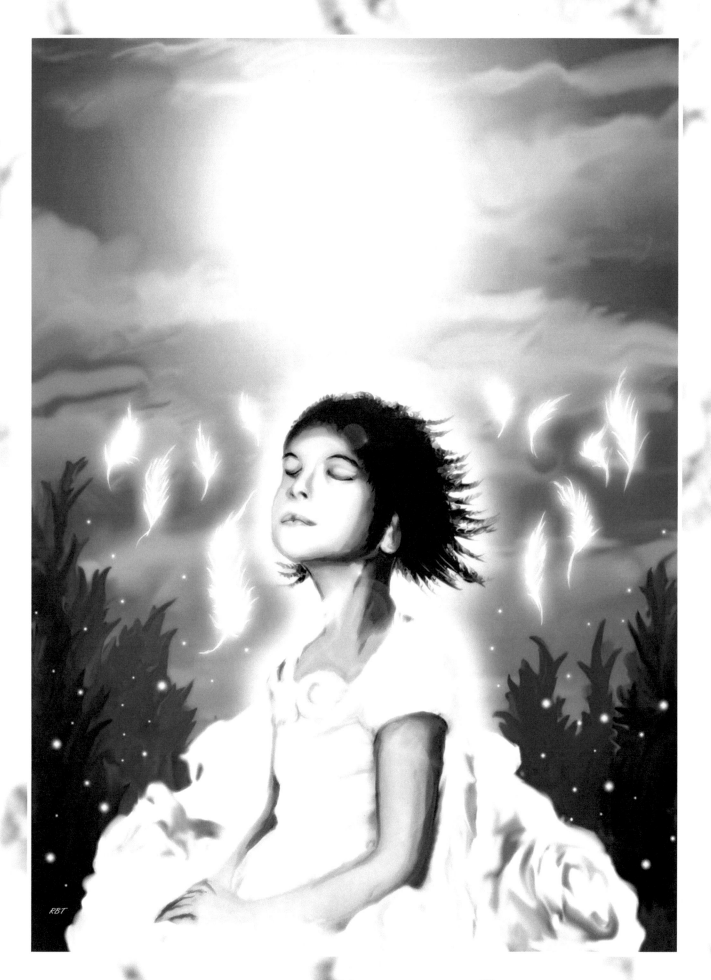

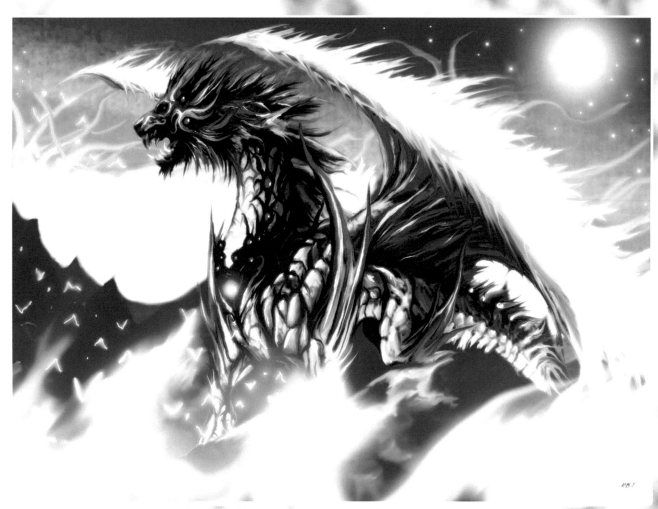

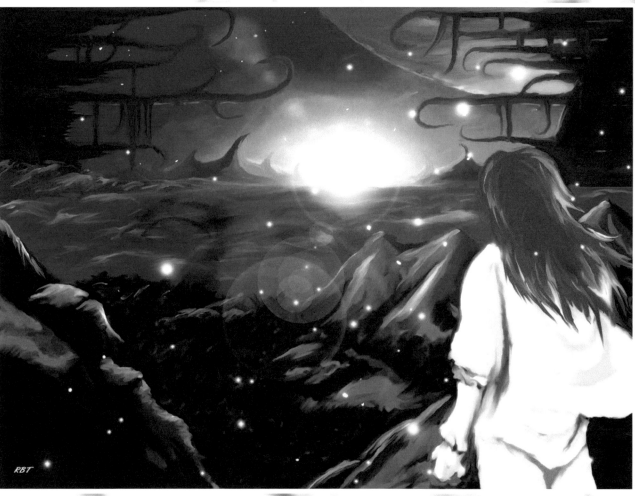

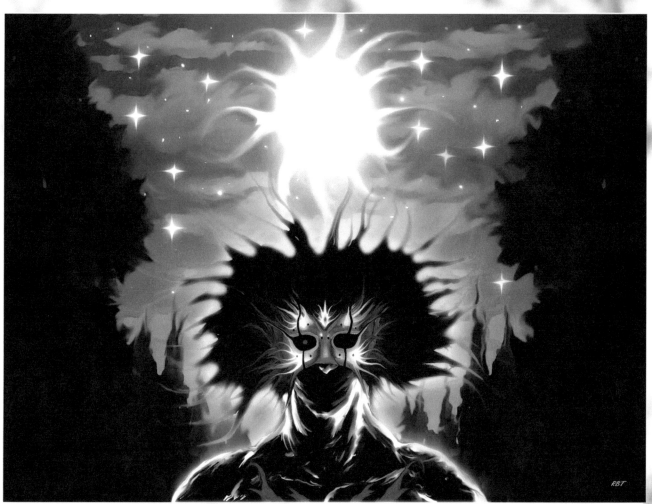

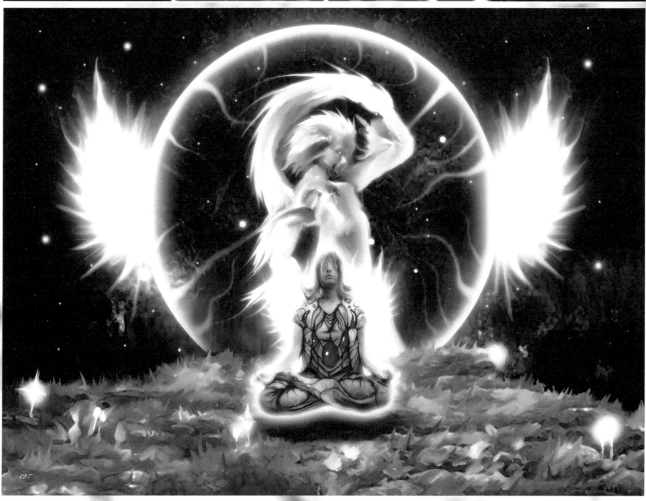

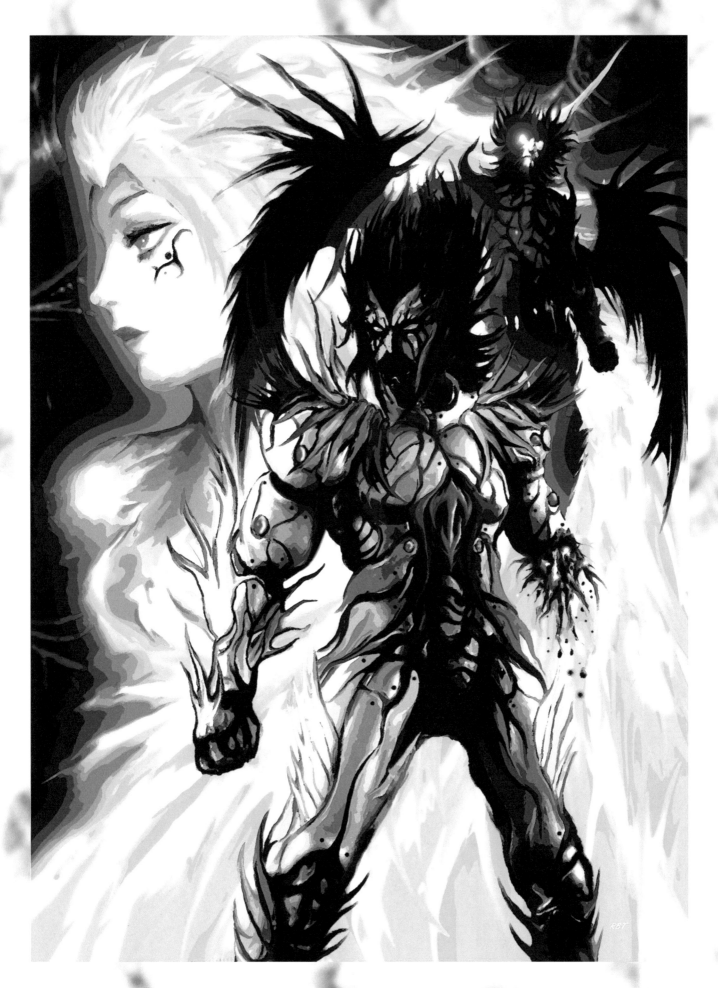

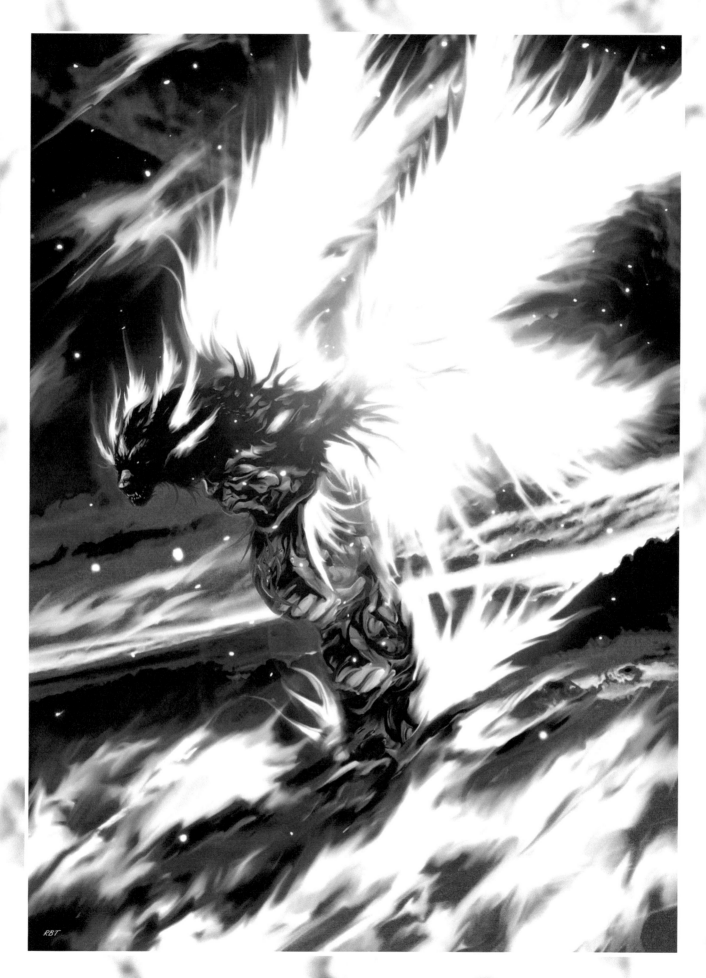

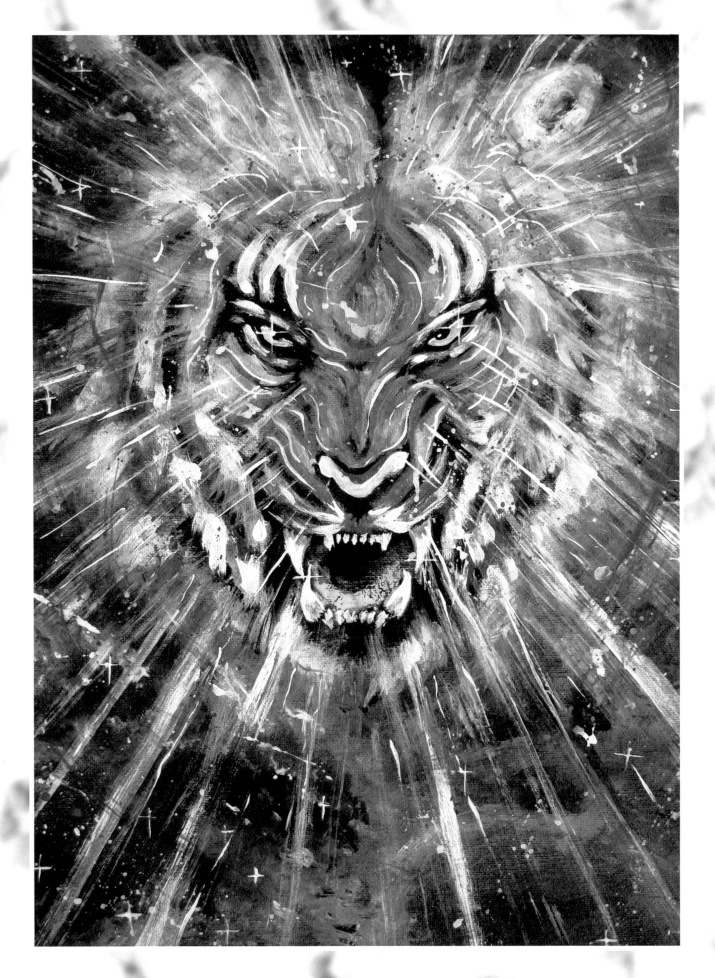

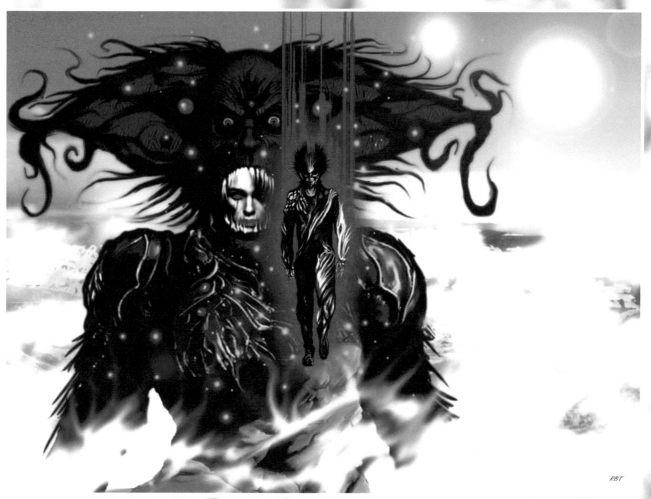

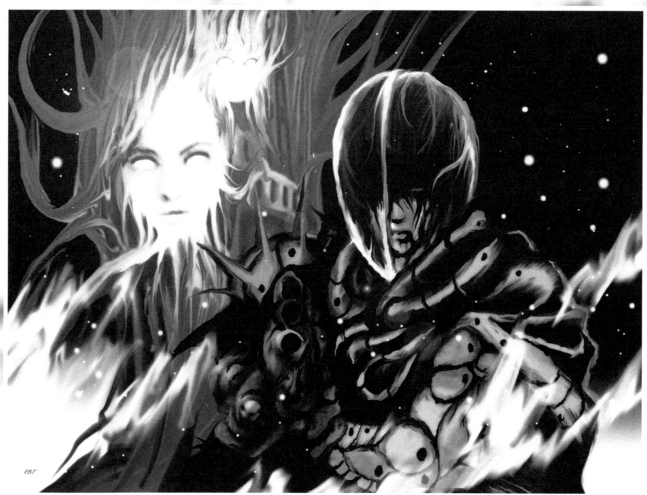

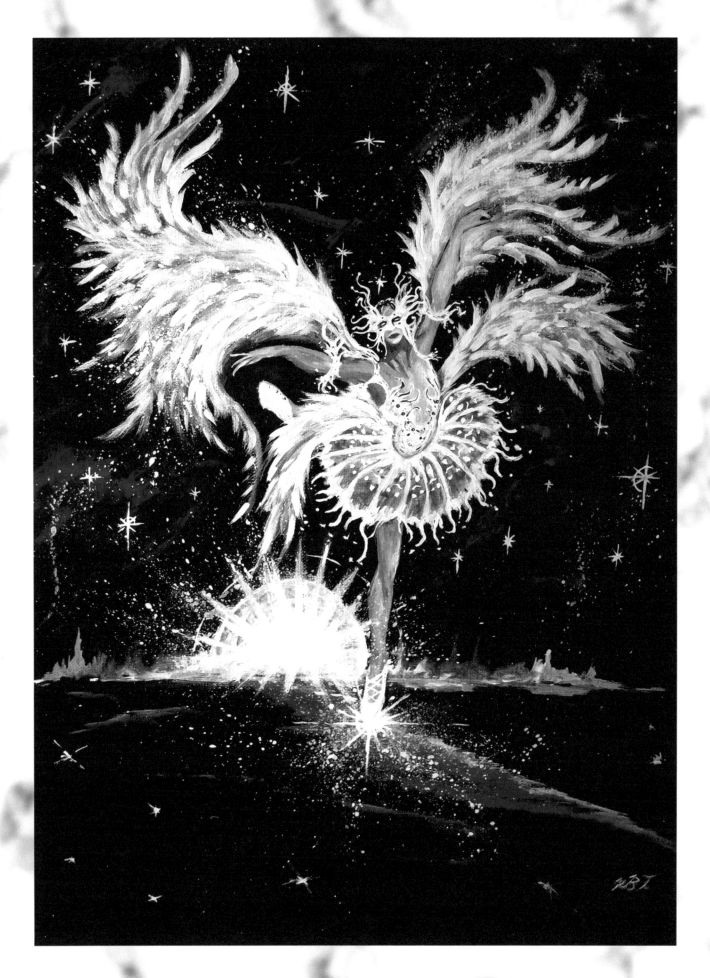

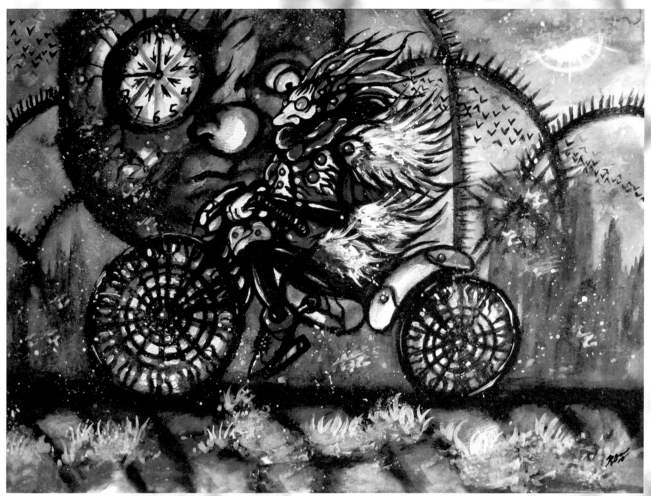

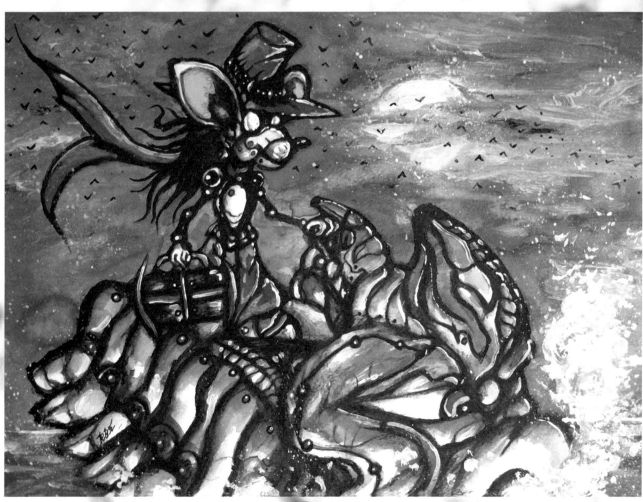

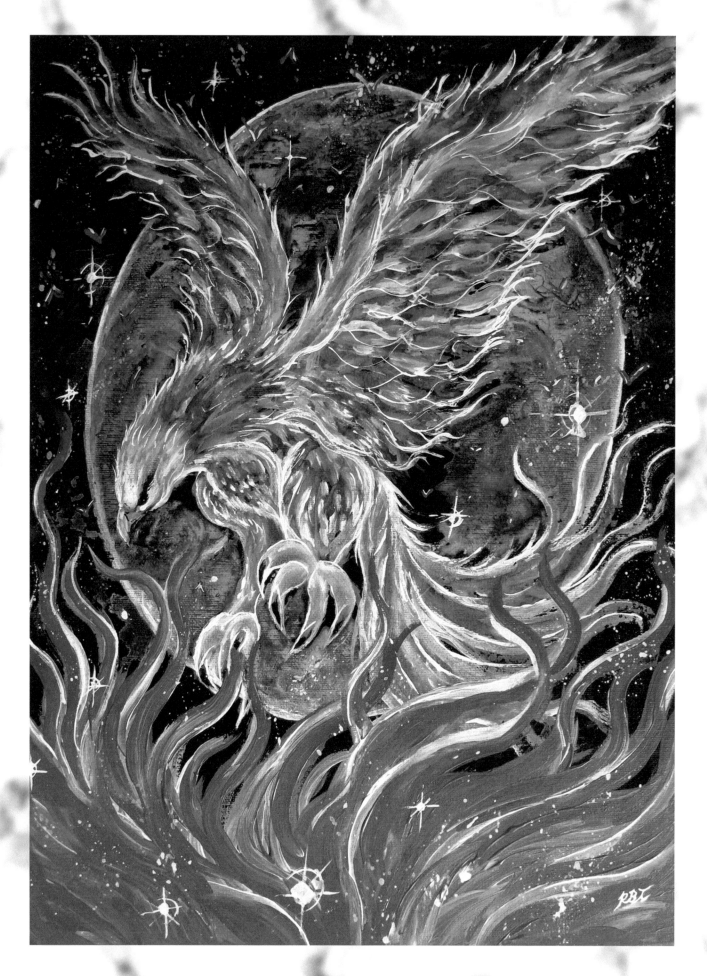

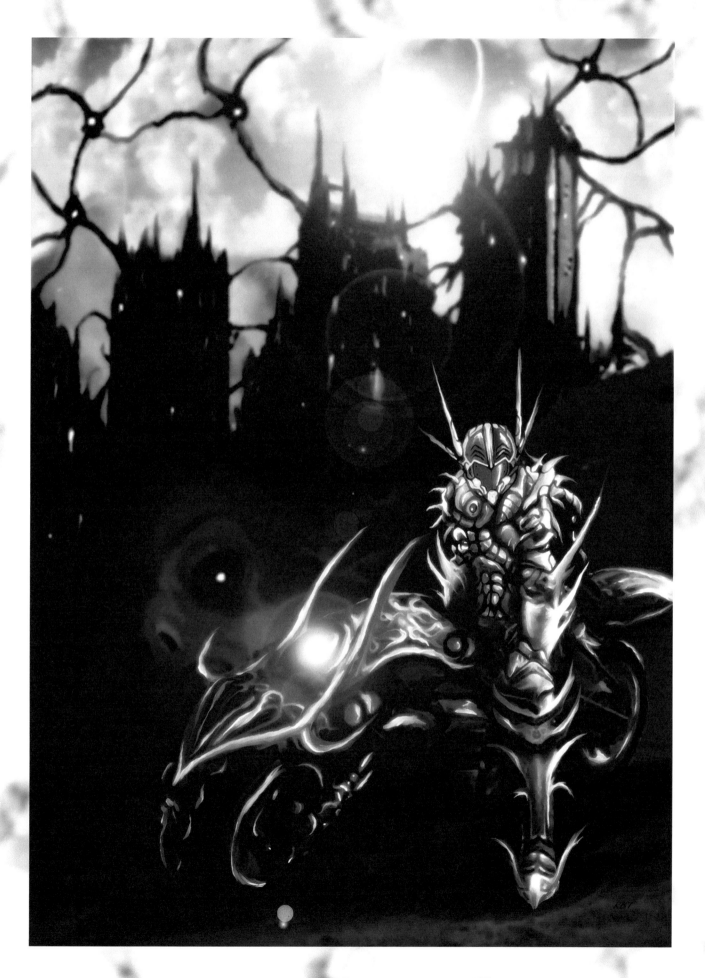

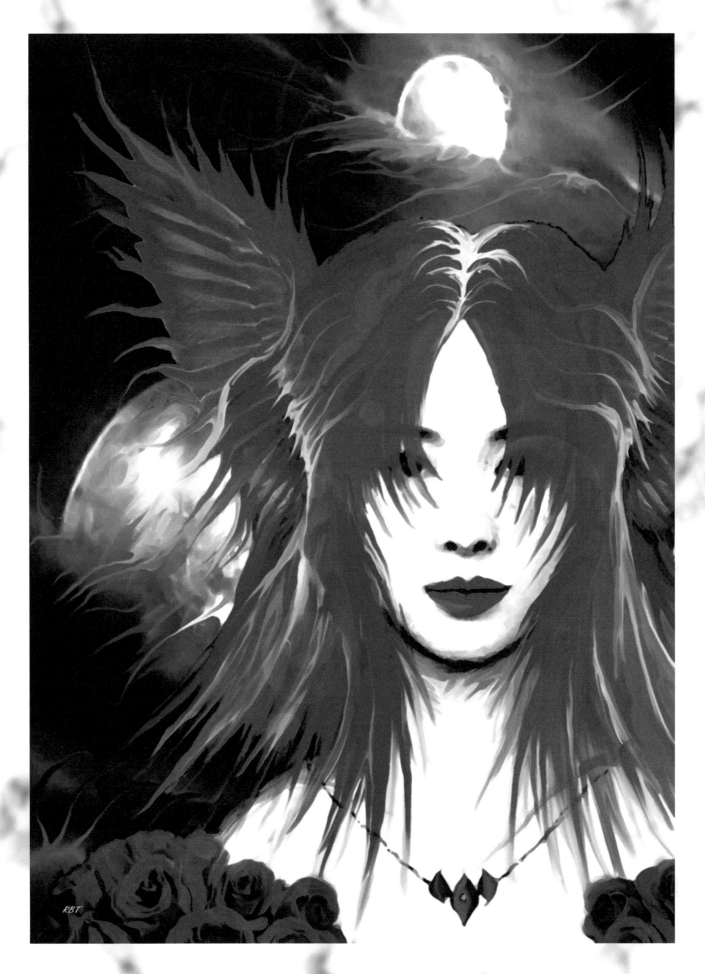

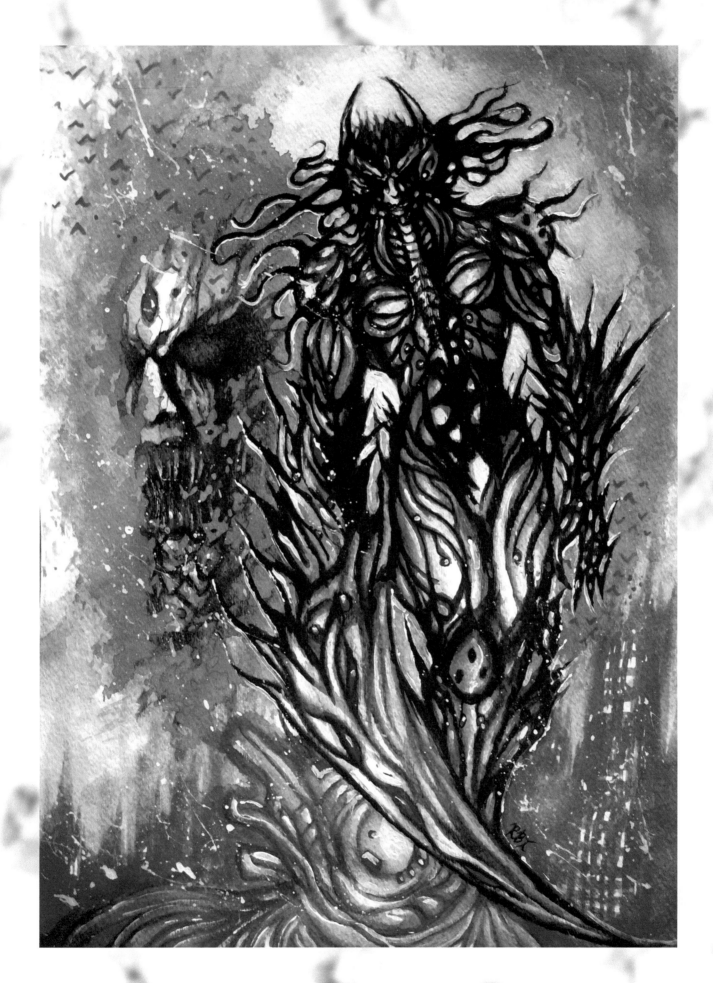

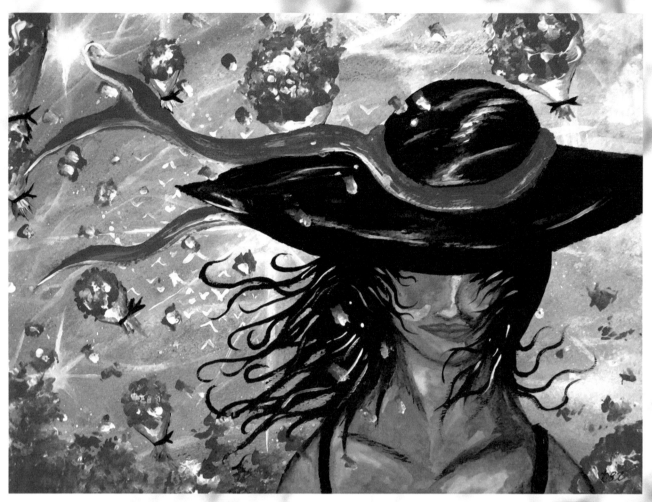

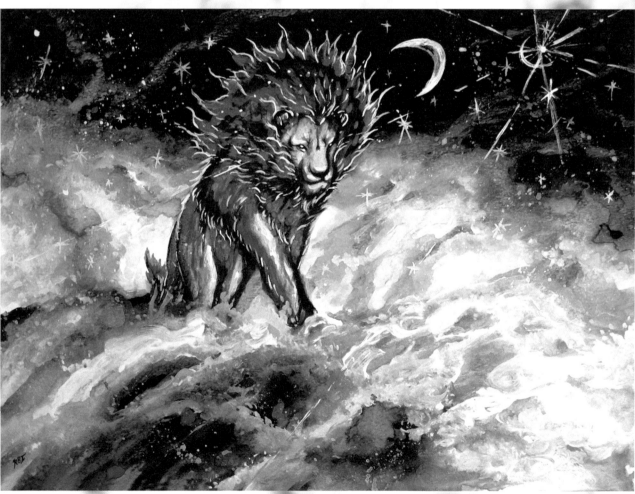

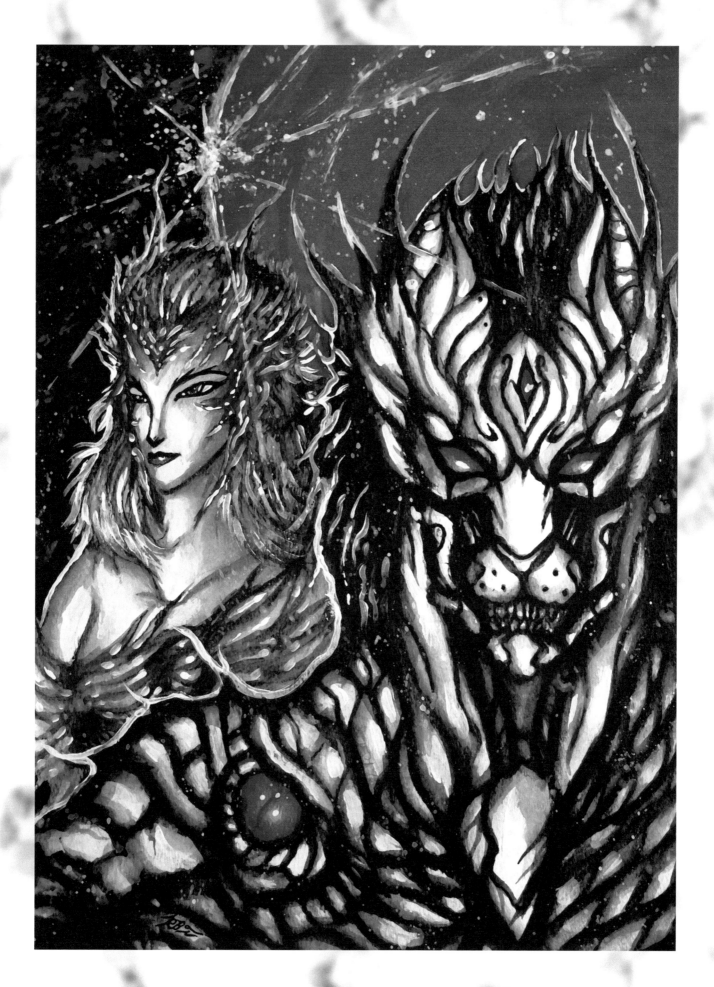

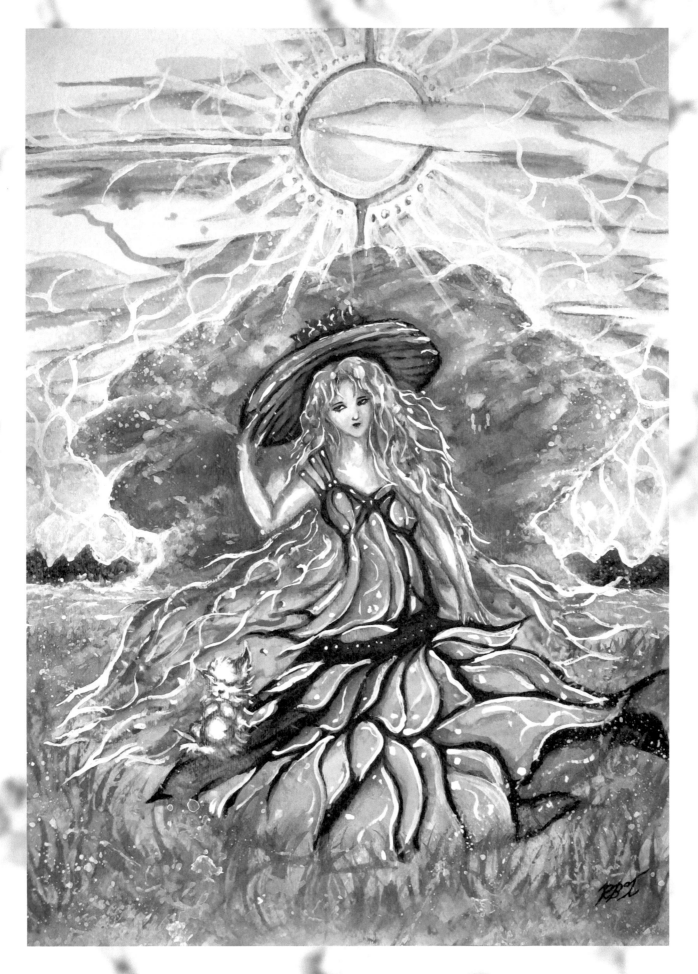

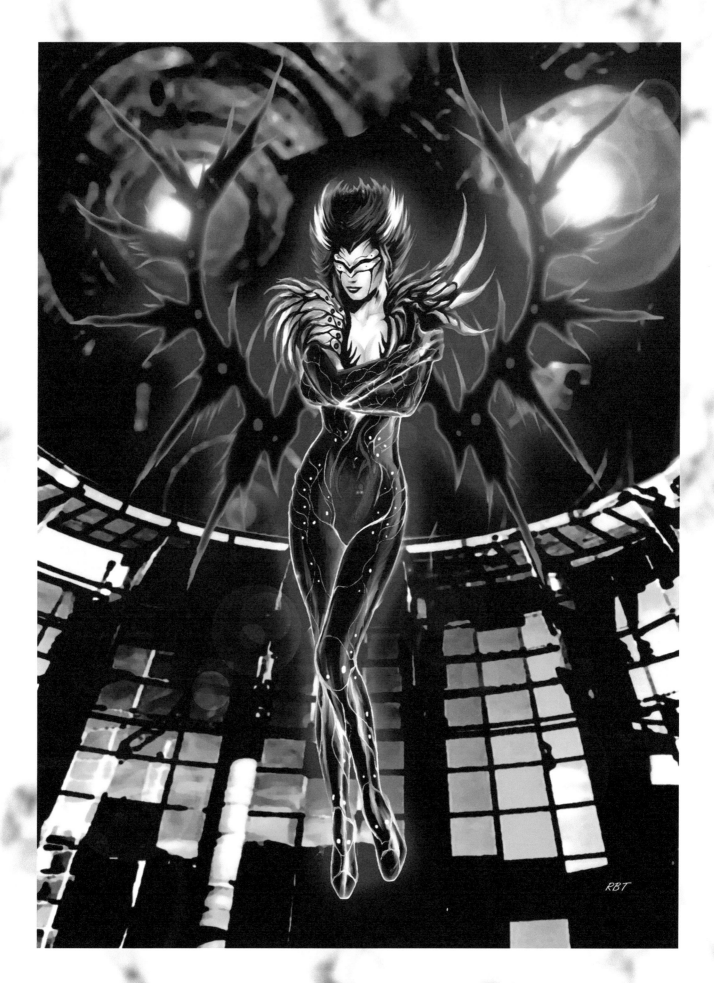

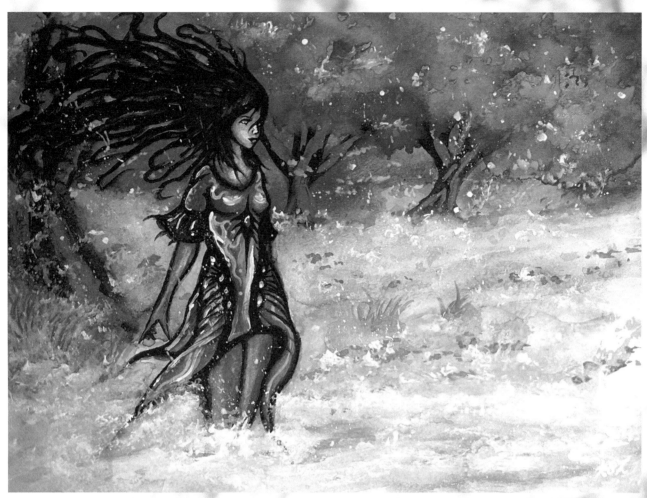

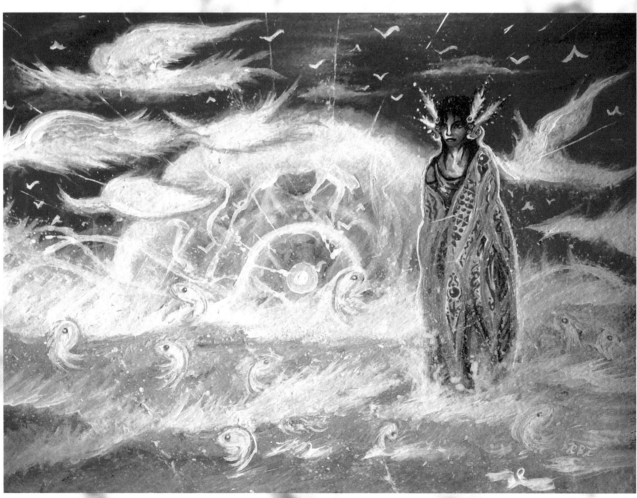

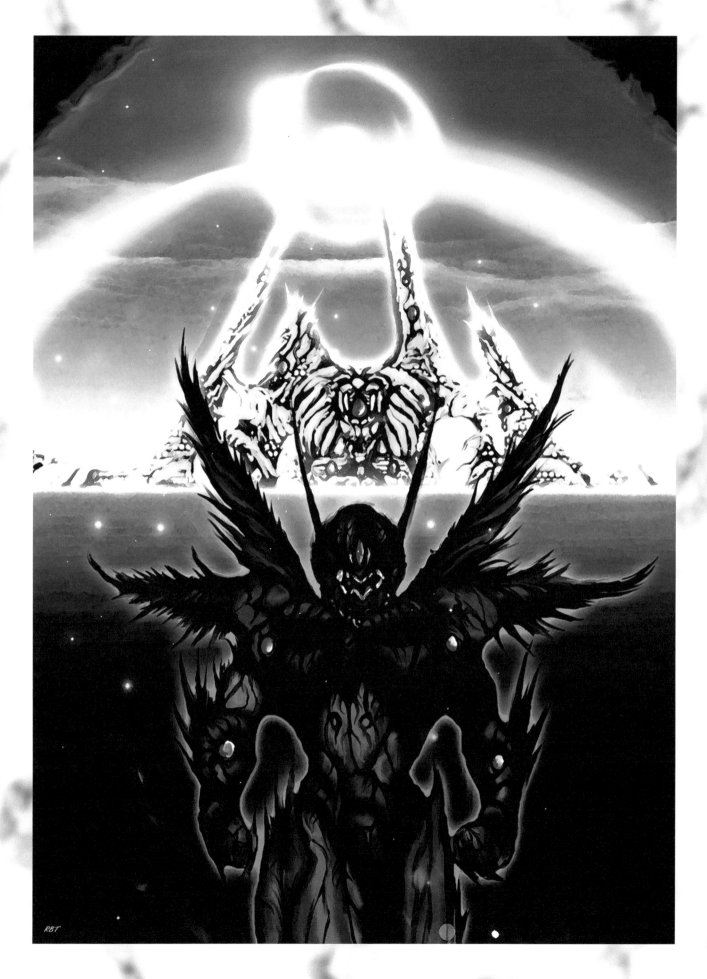

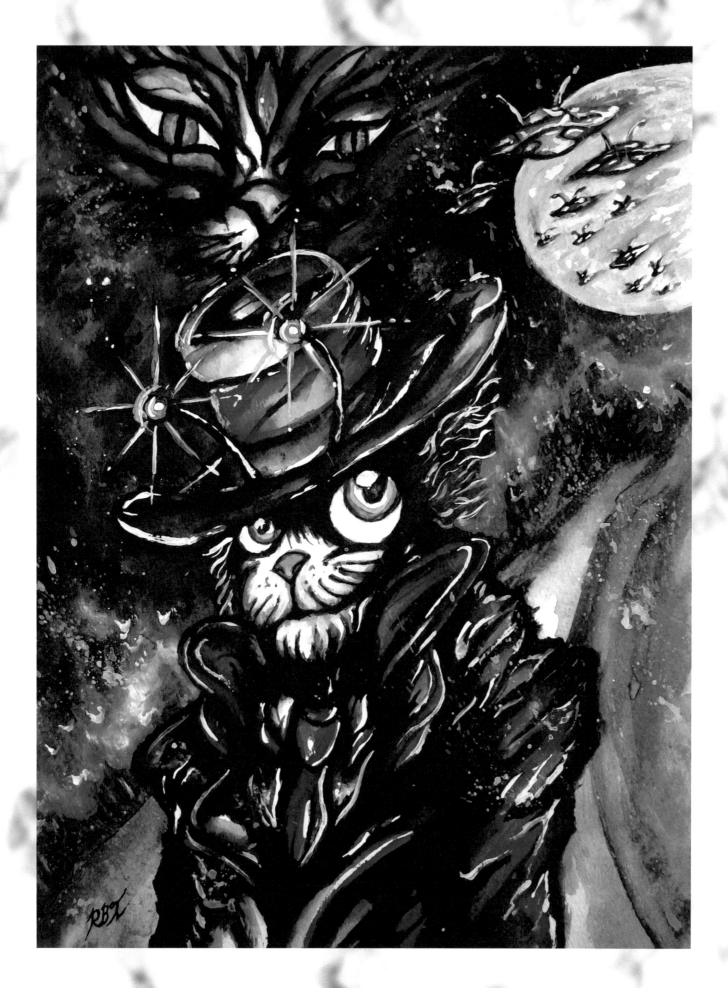

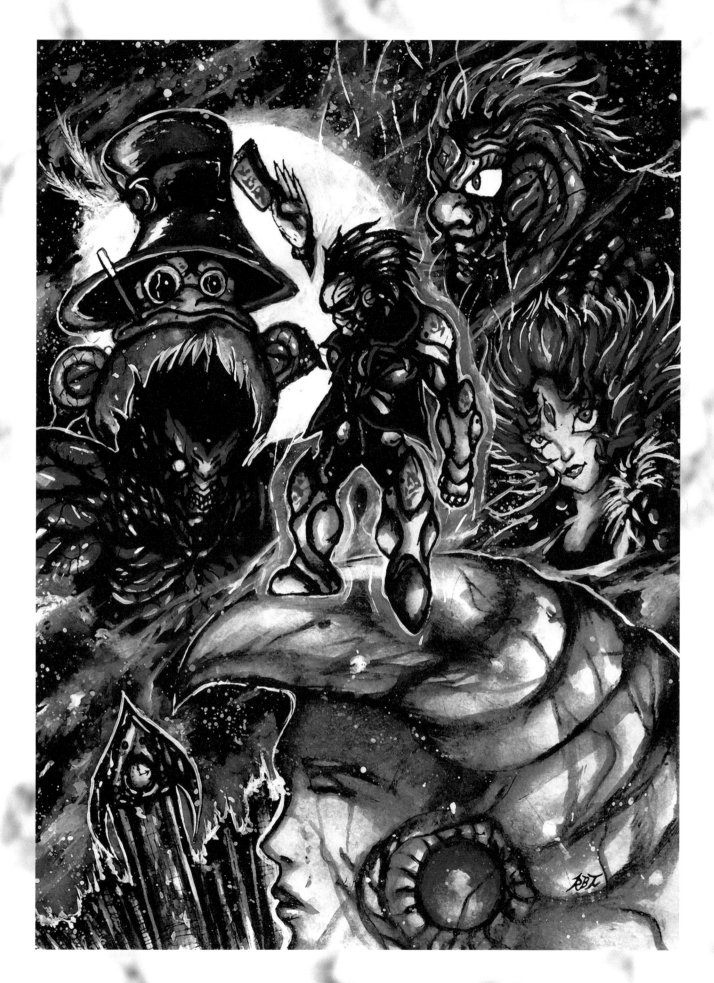

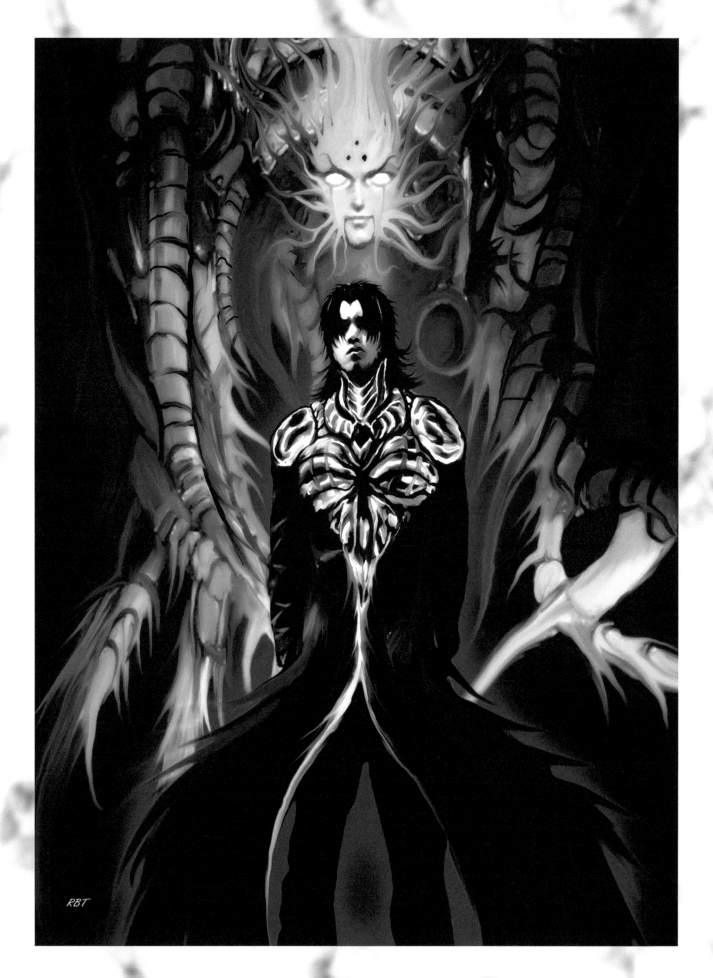

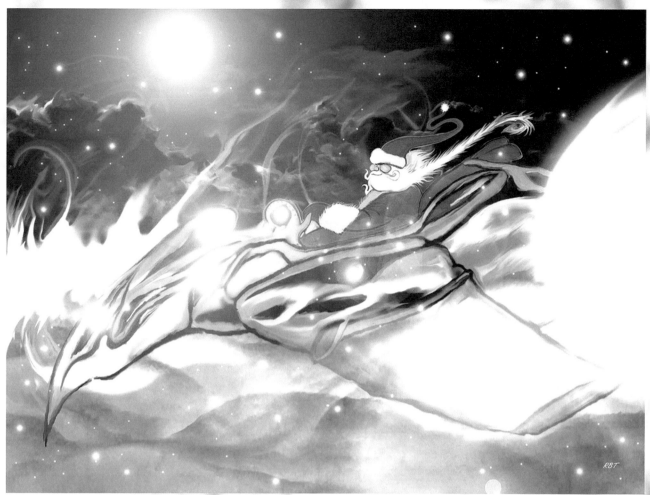

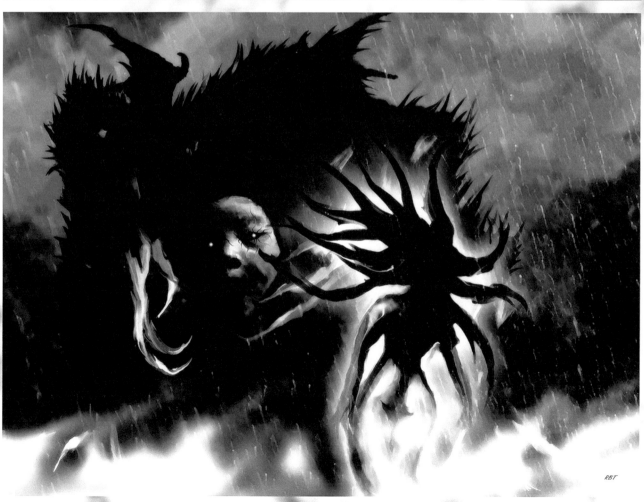

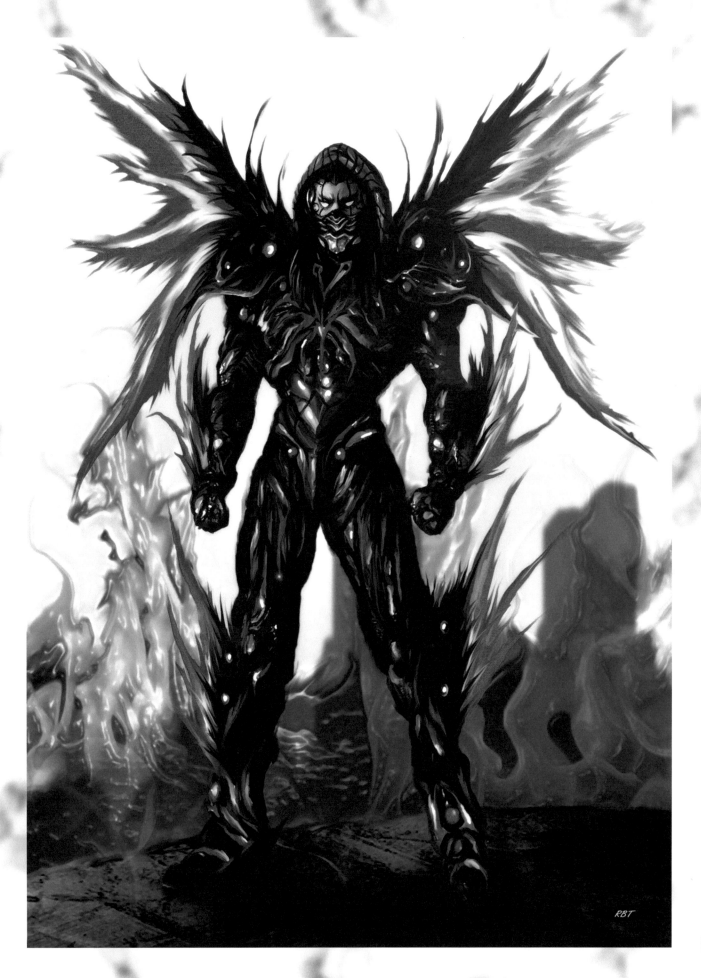

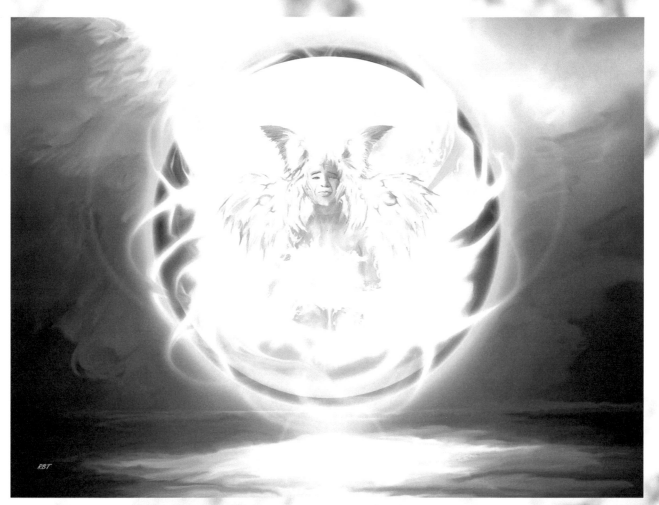

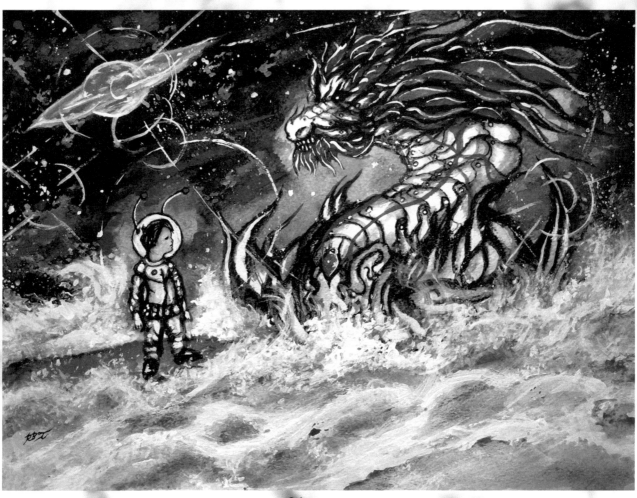

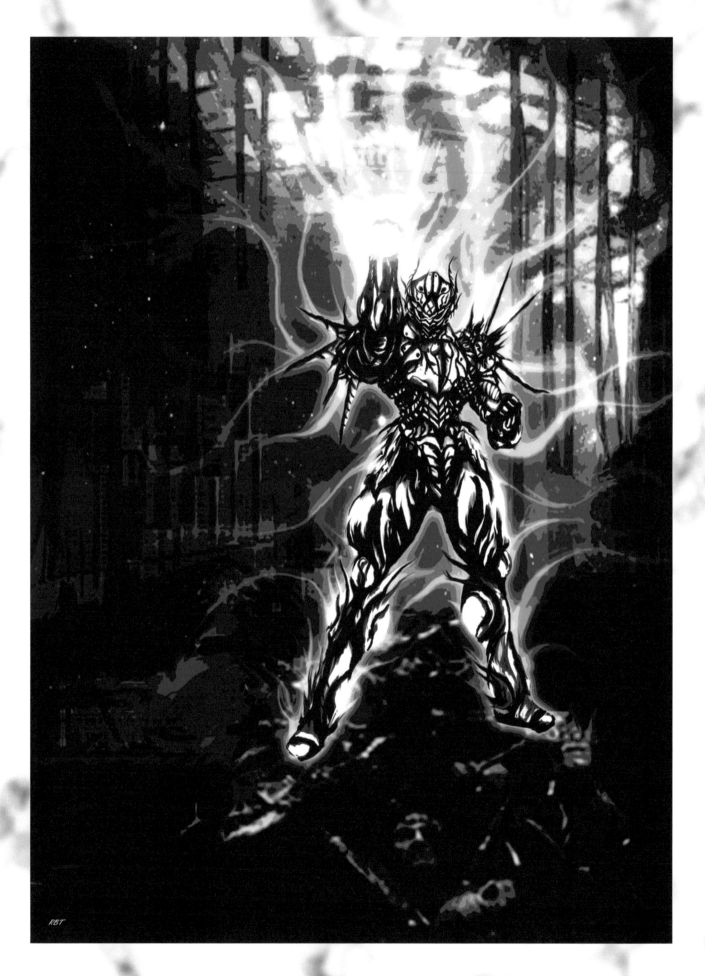

RBT

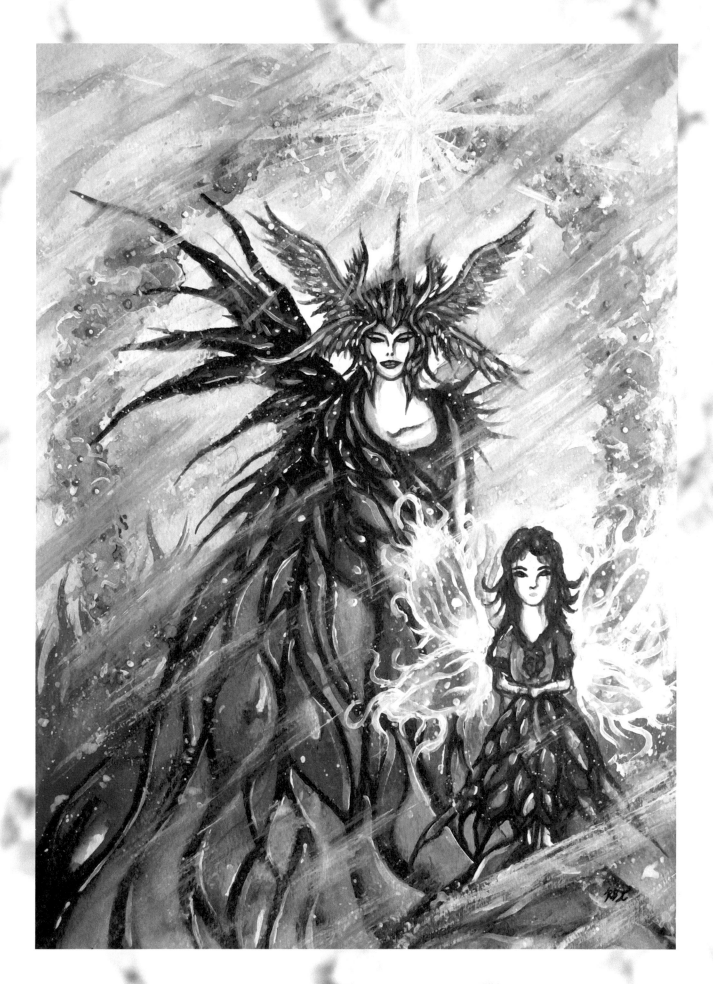

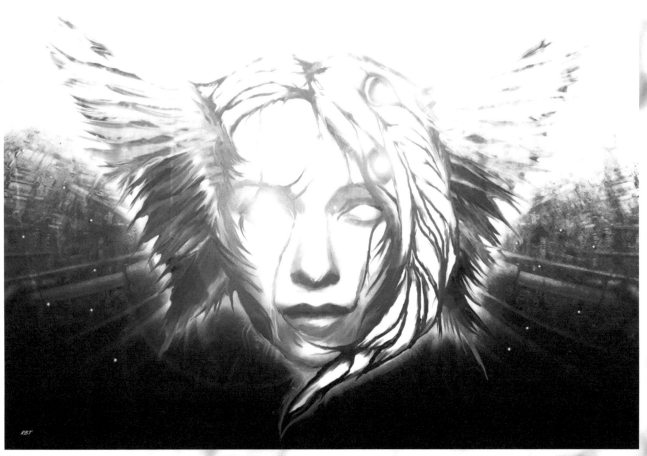

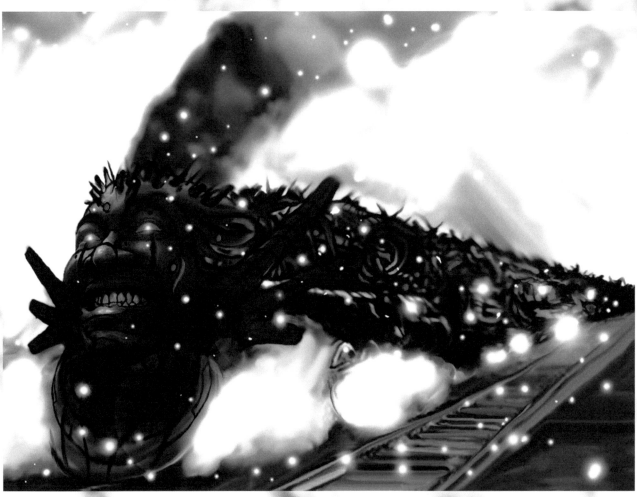

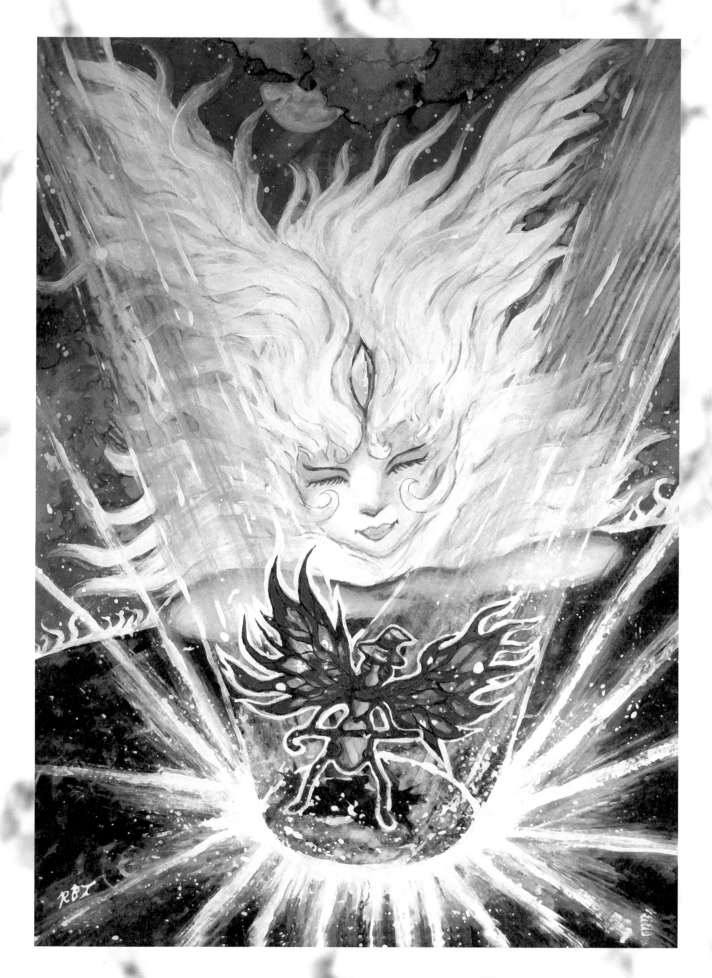

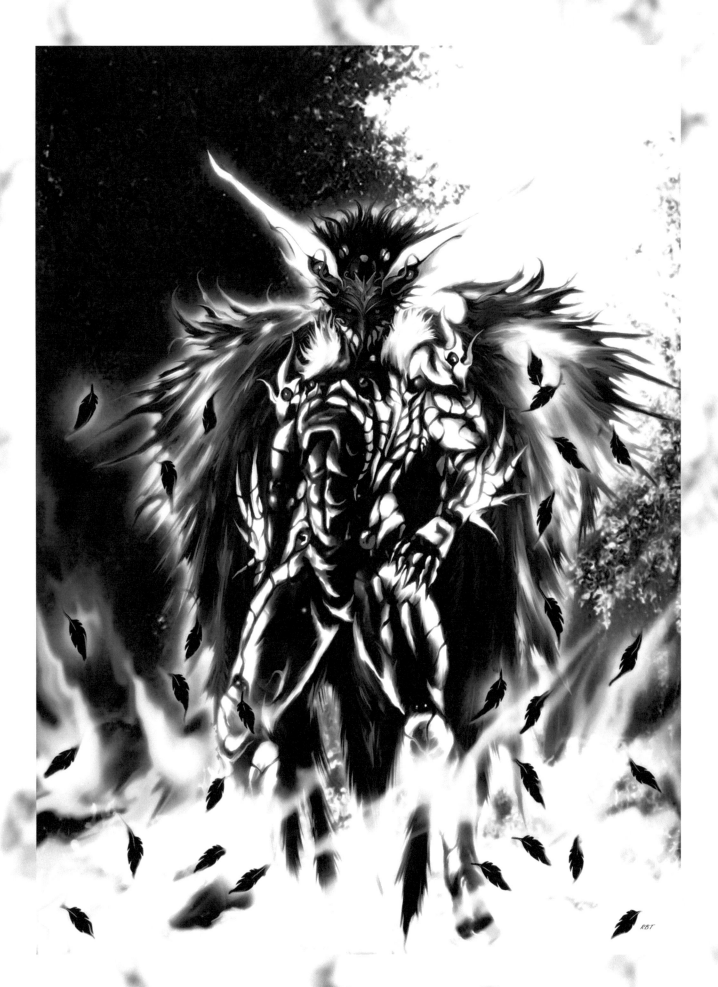

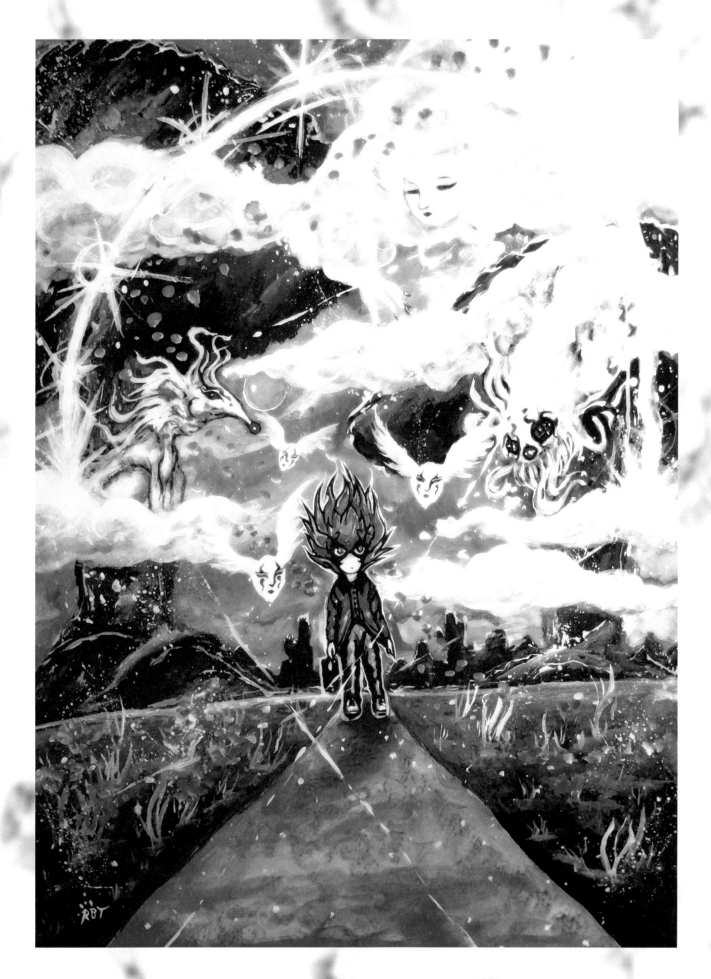

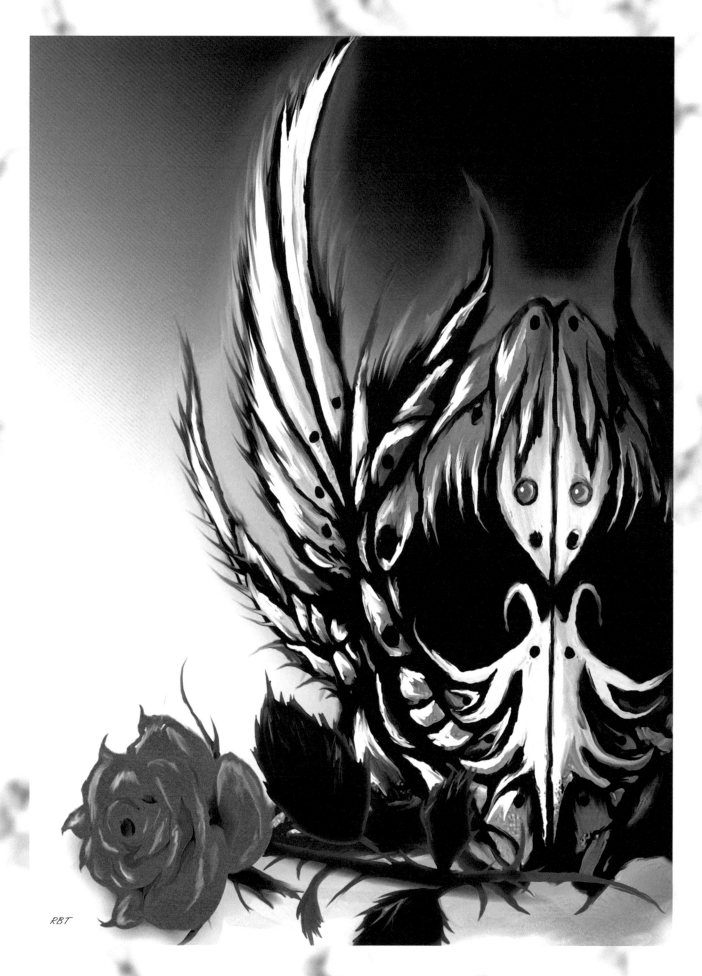

RBT

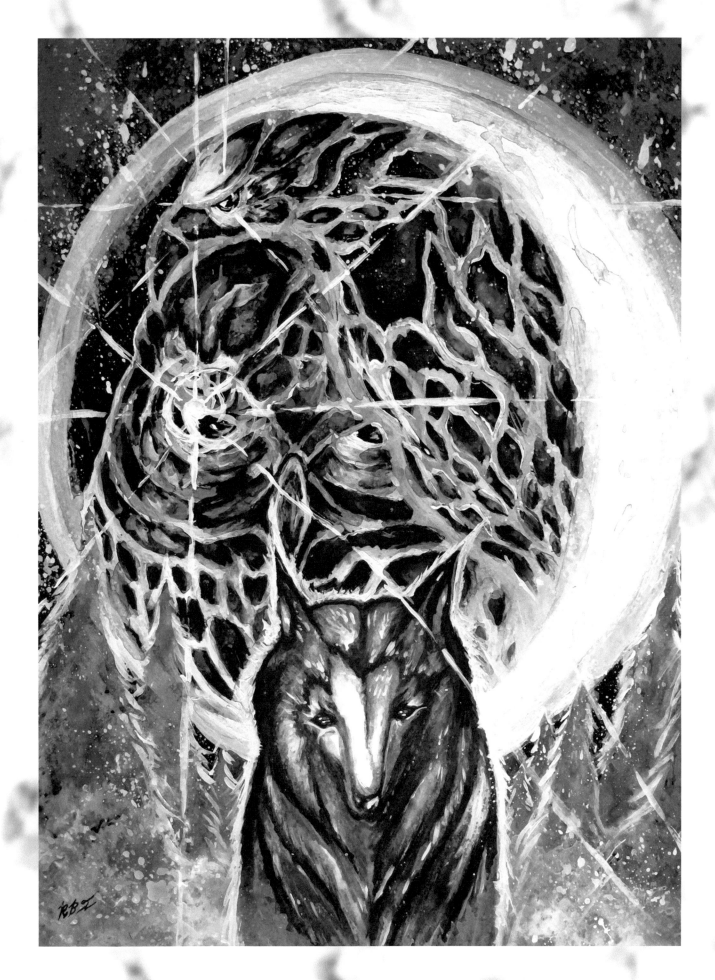

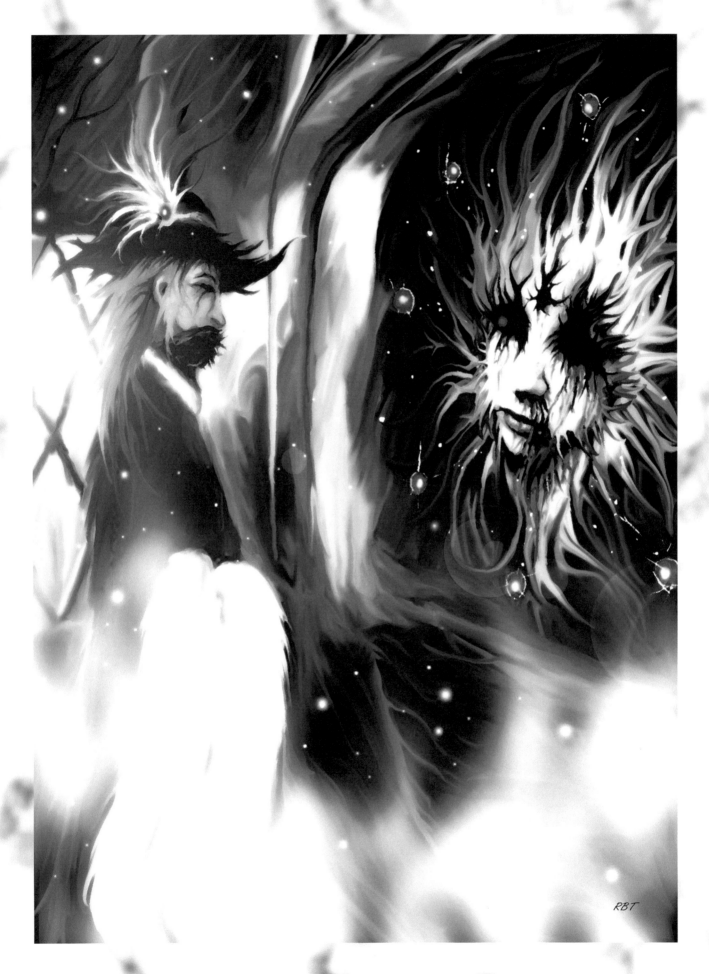

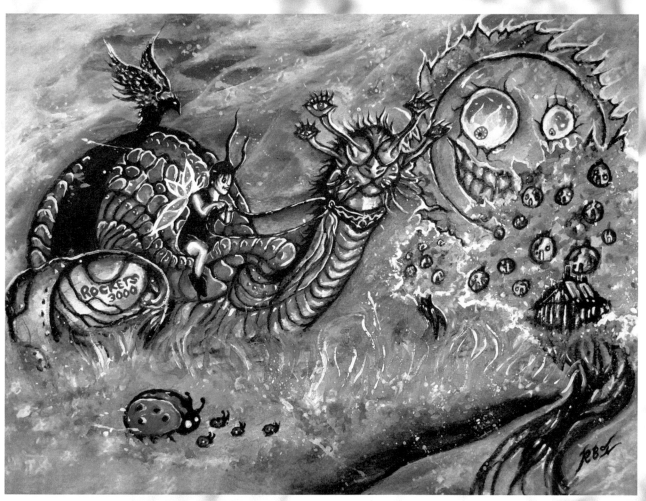

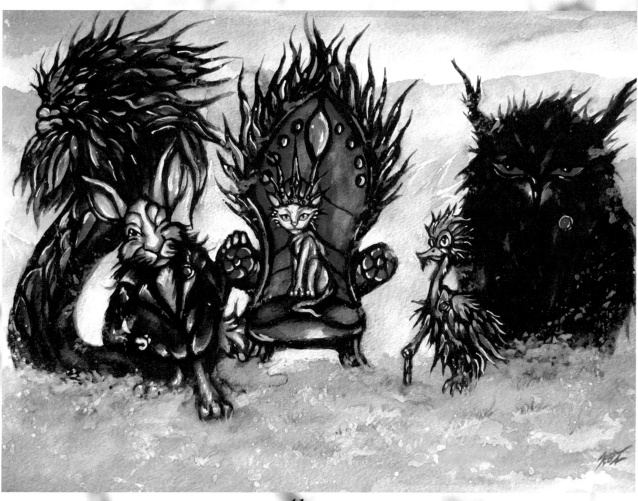

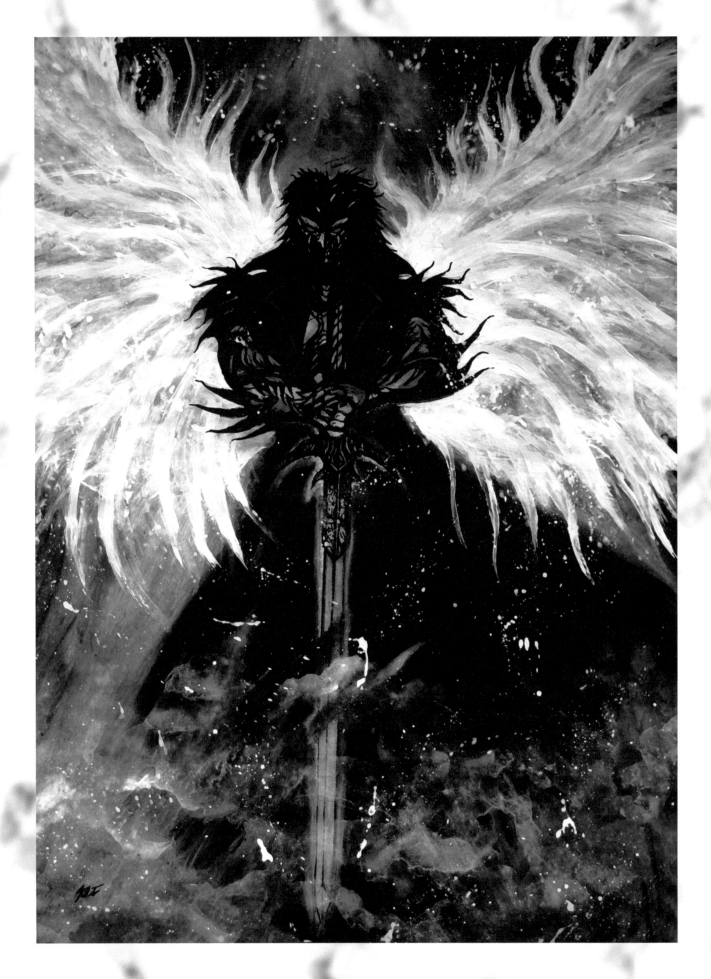

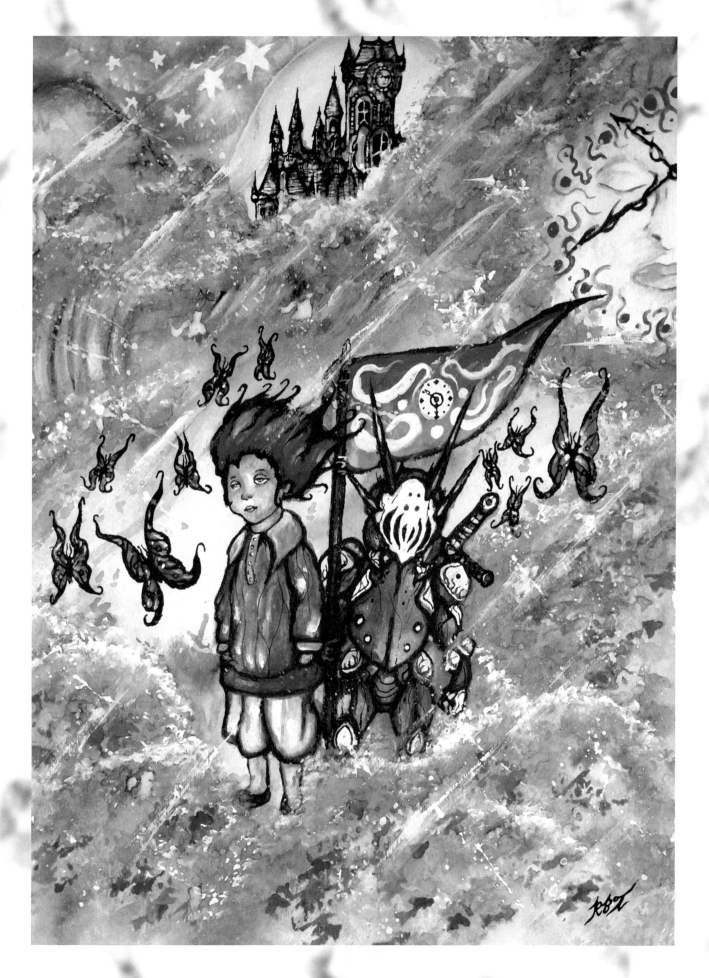

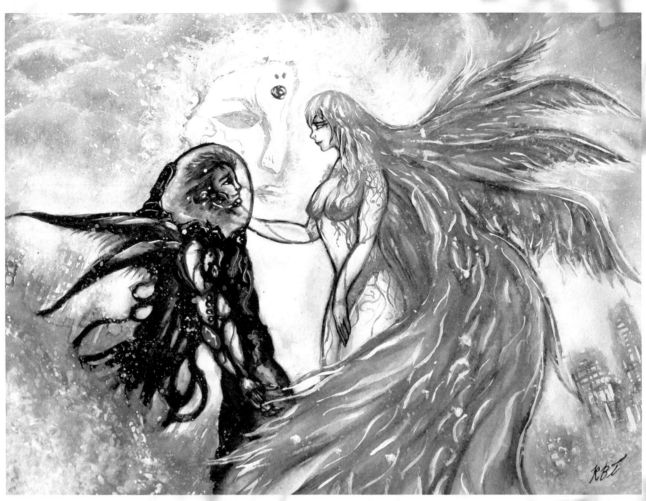

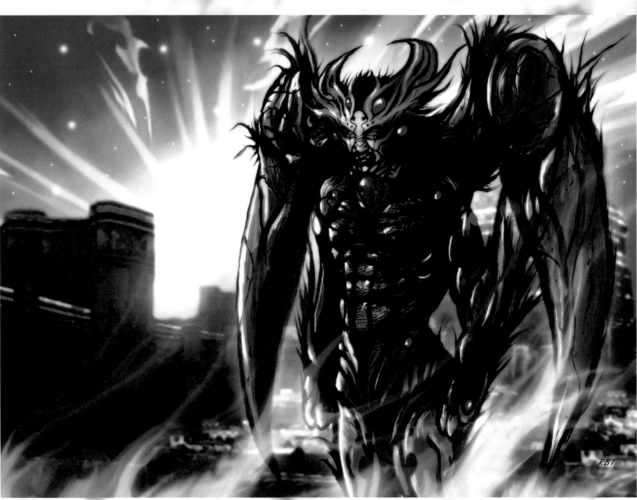

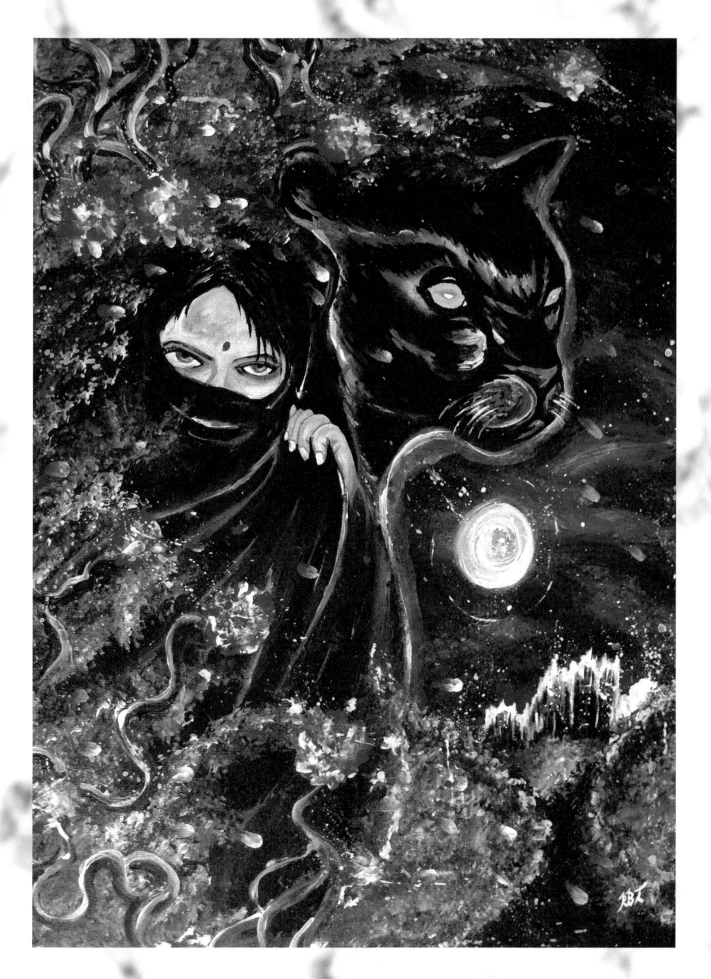



45

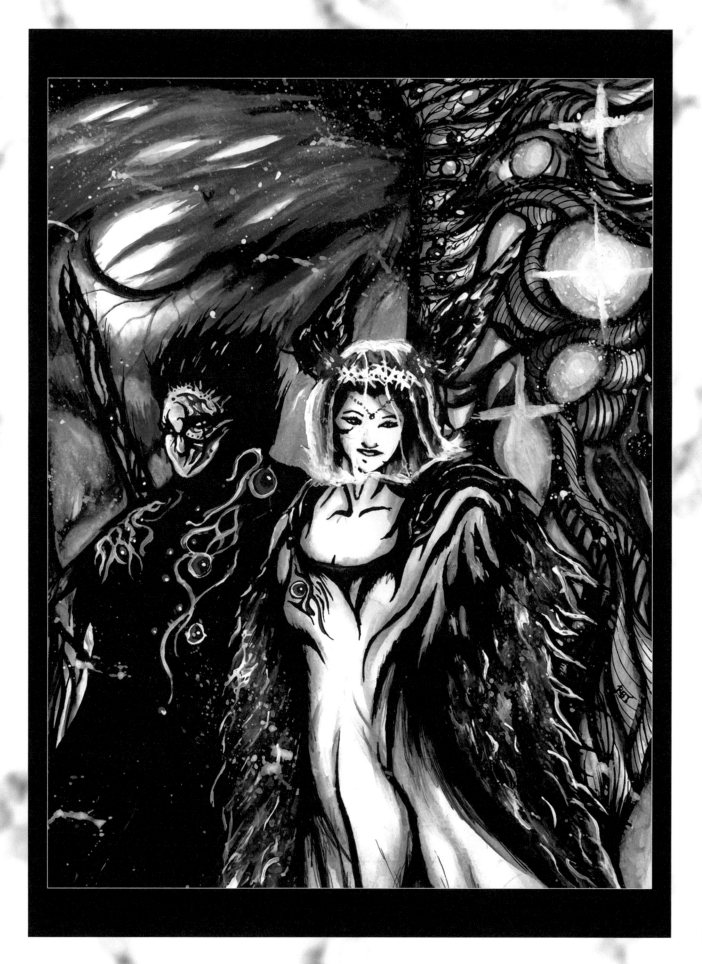

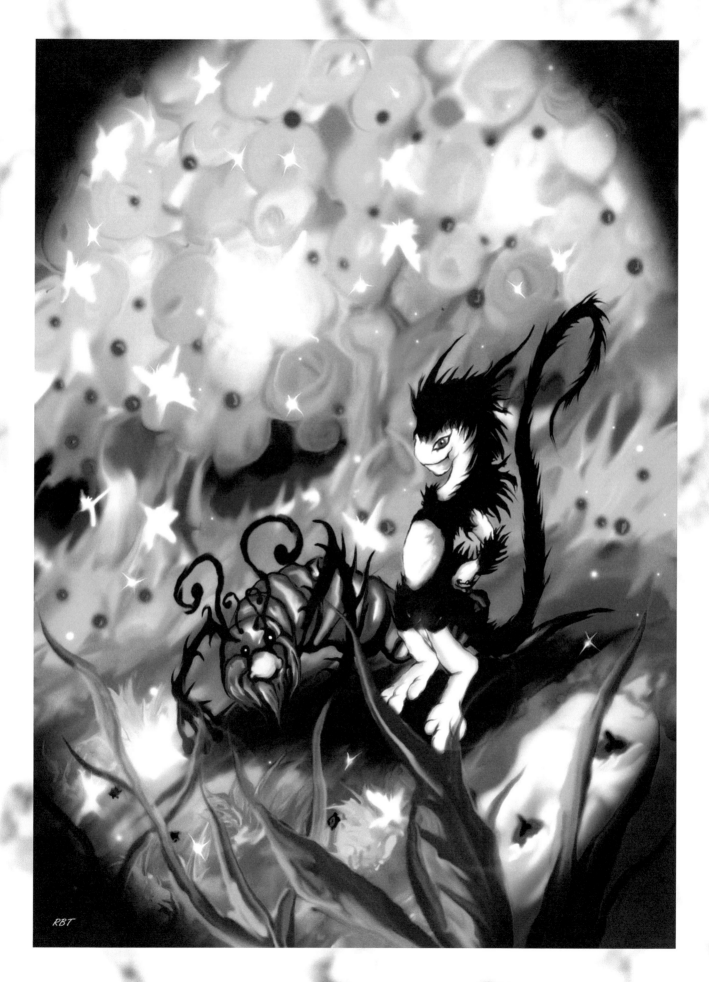

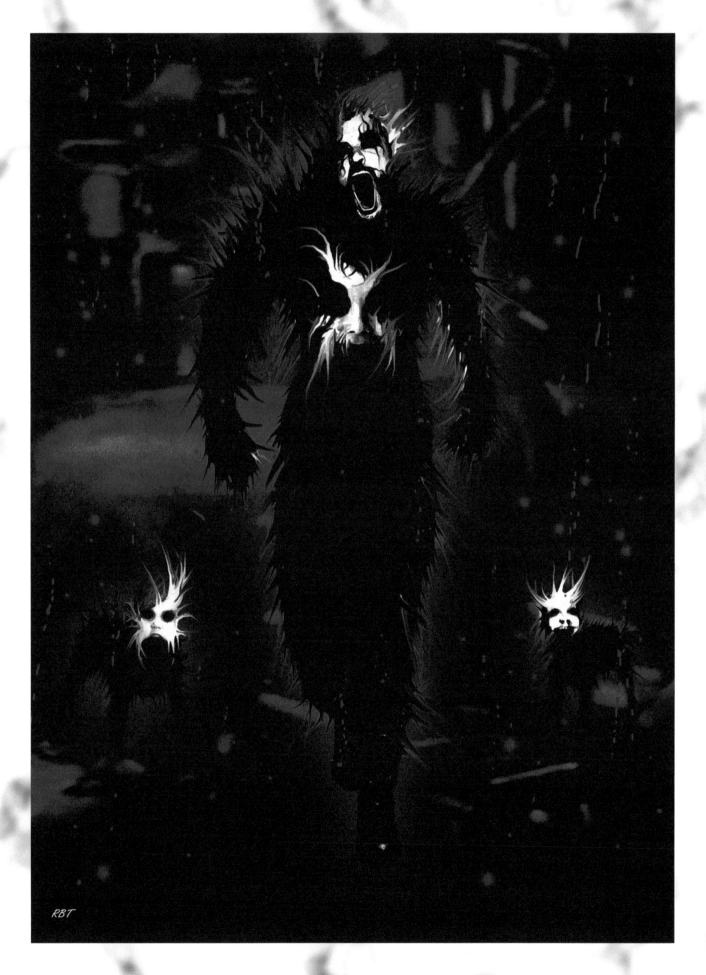

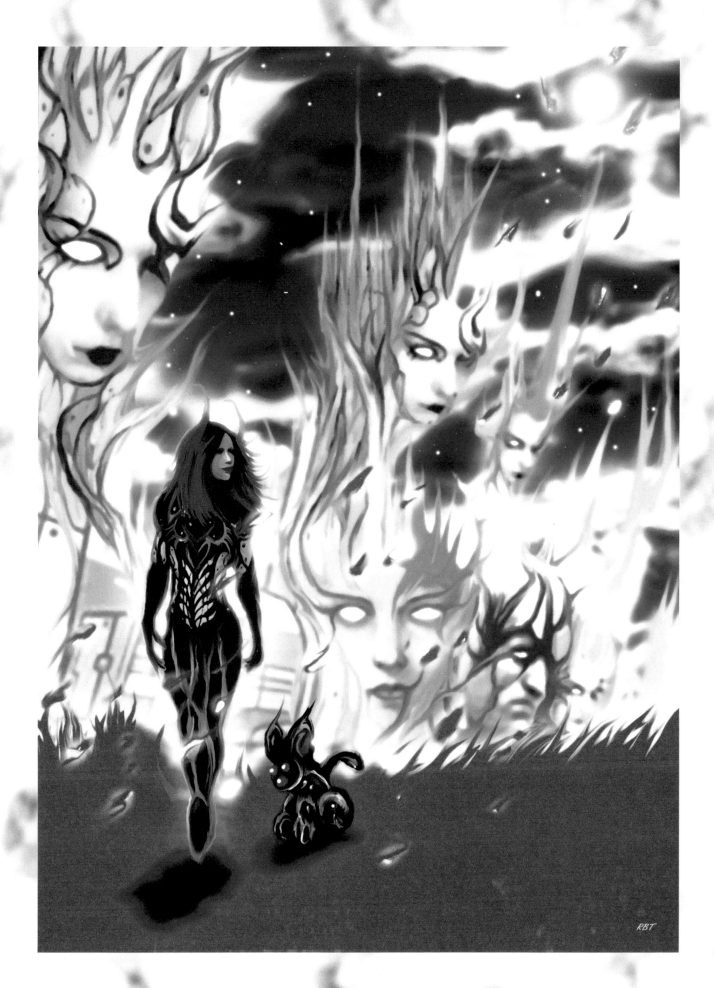

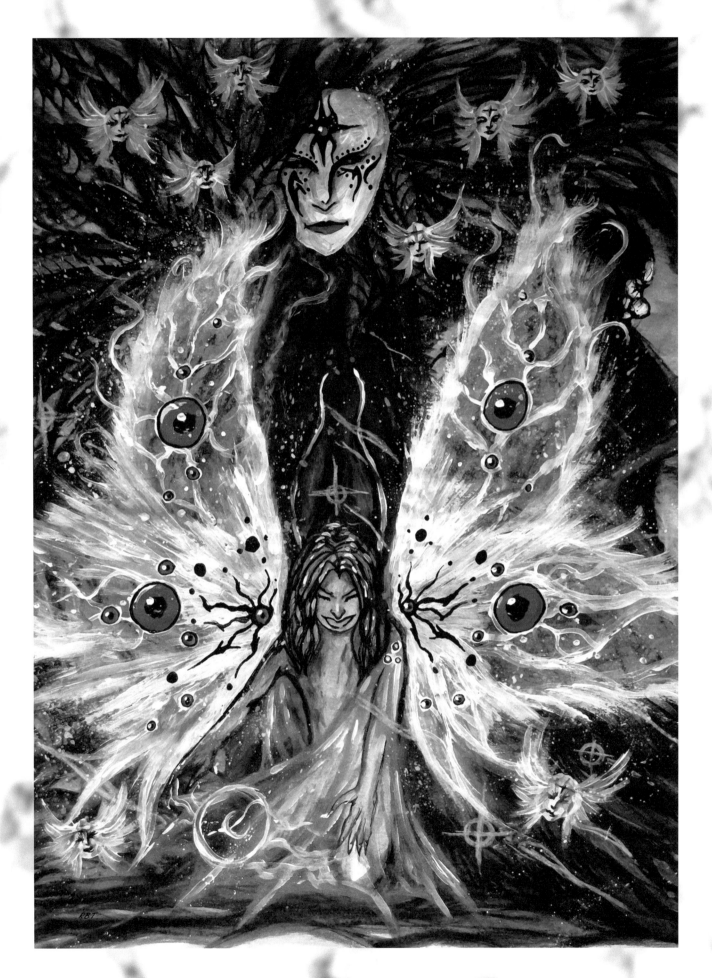

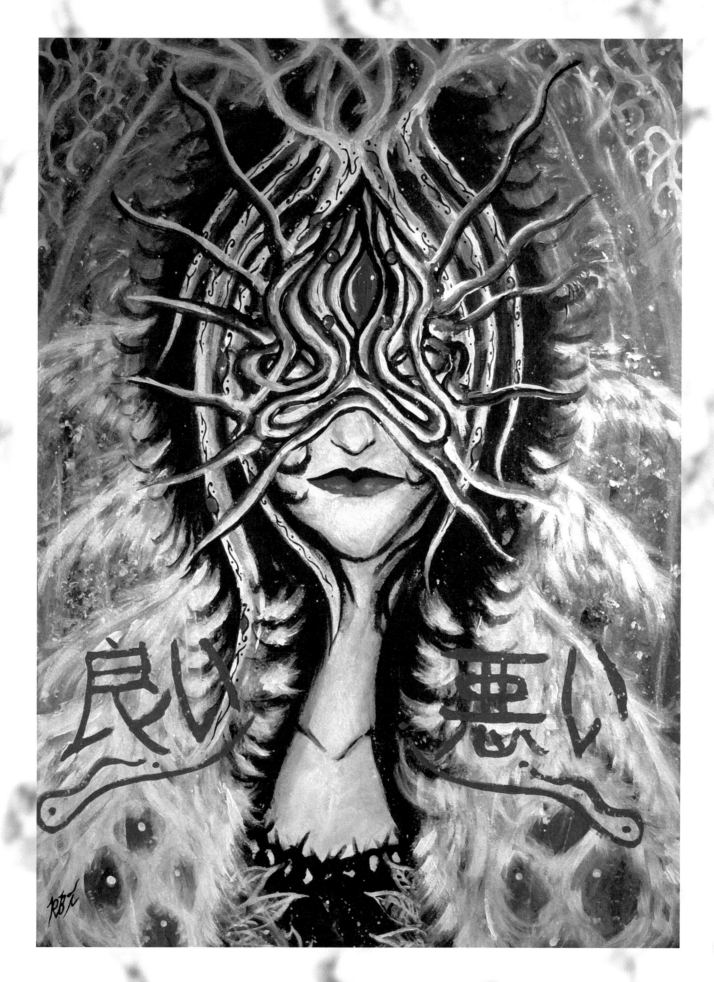

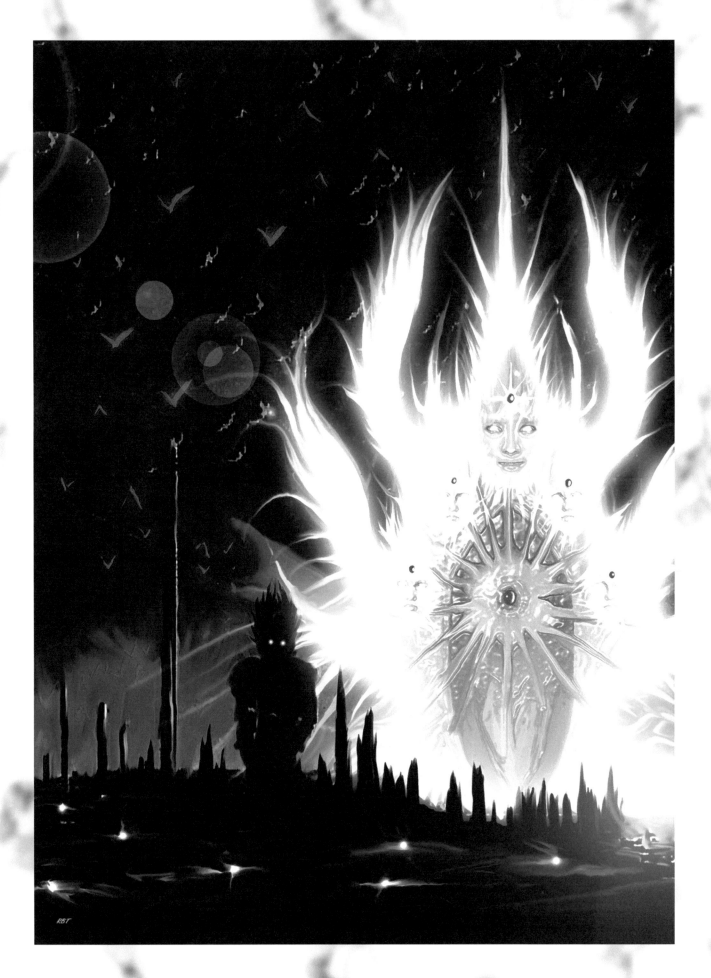

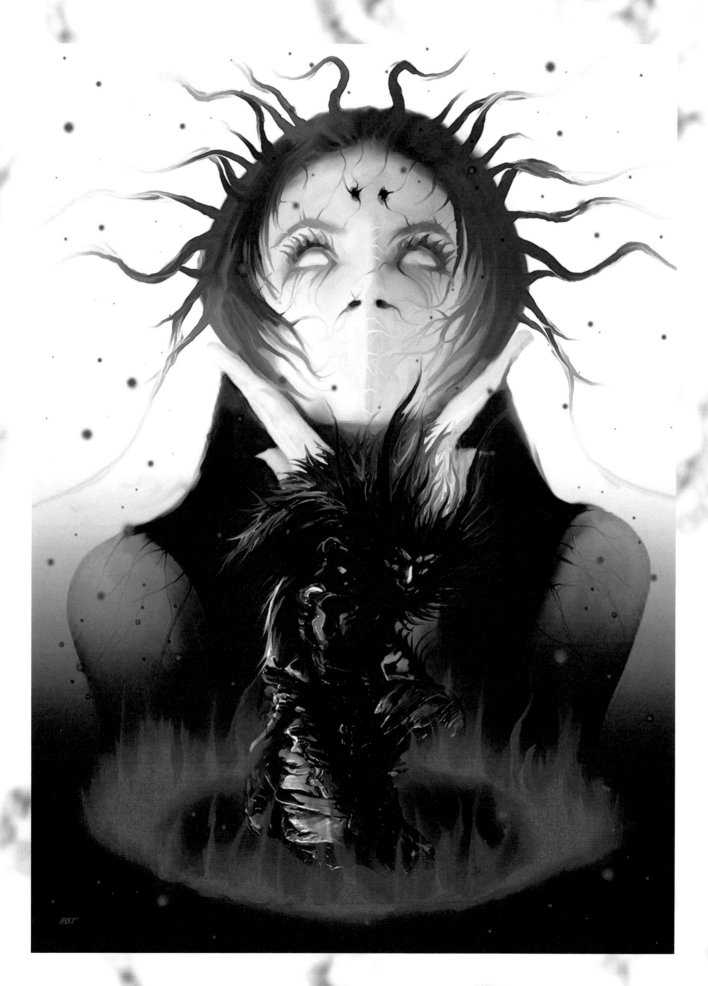

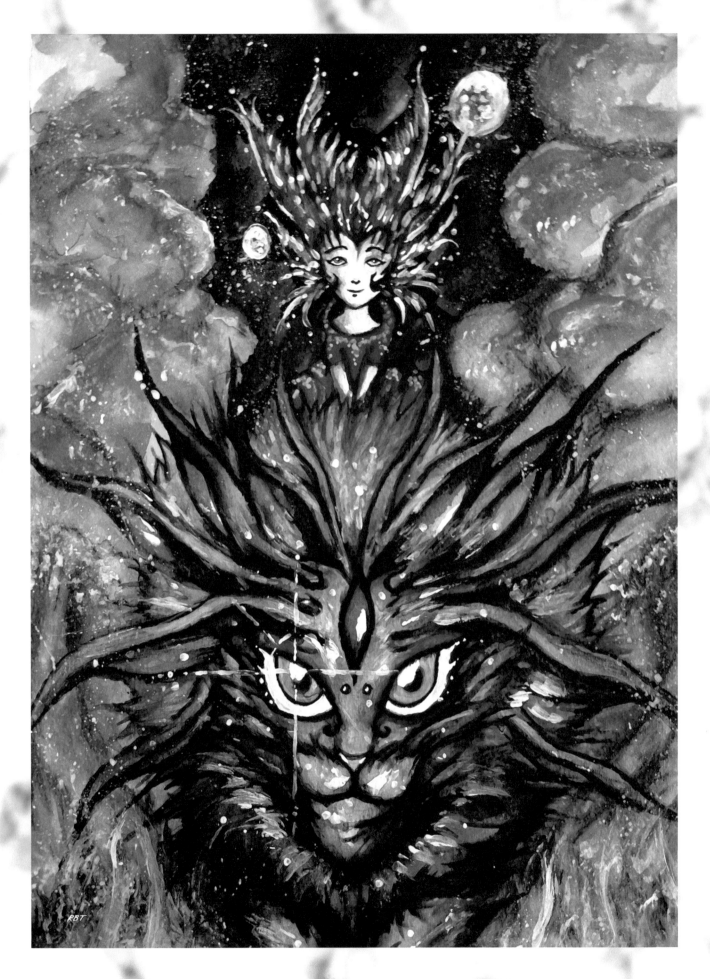

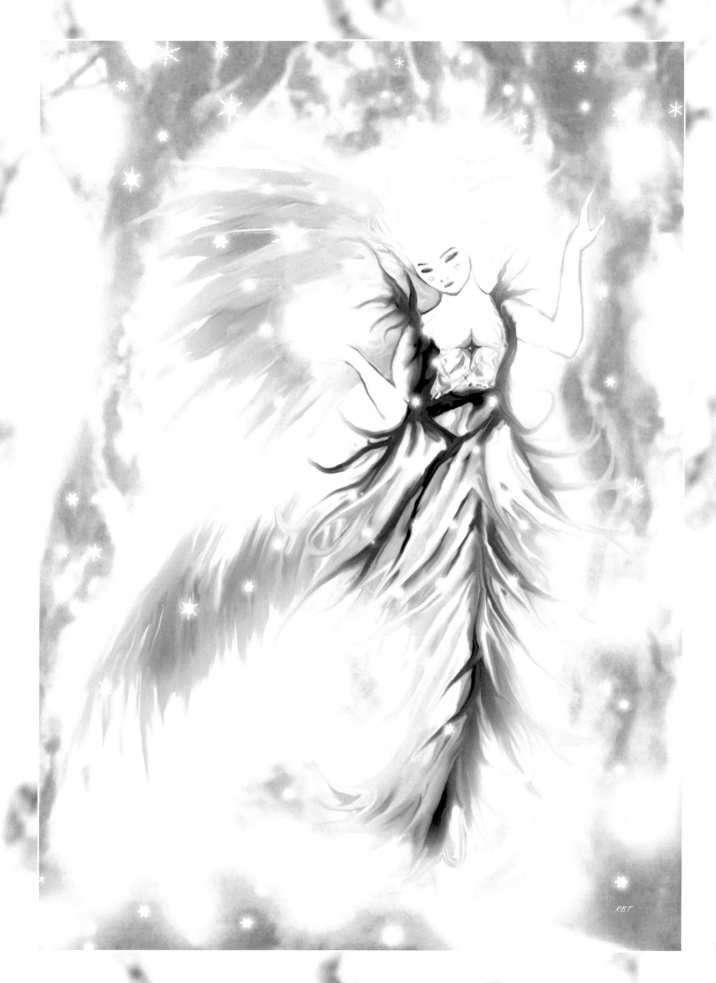

LIST OF ARTWORKS

Special Thanks To:

Catherine P. Hailey

Constance M. Tyler

Jacqueline France

John Wooten

Marc Adona

ILLUSTRATOR RICHARD B. TYLER
WAS BORN ON APRIL 11, 1982 IN
MONTEREY, CALIFORNIA.
HE STUDIED AT THE ART
INSTITUTE OF WASHINGTON
WHERE HE RECEIVED A
BACHELOR'S DEGREE IN
THE FINE ARTS. HIS WORK
HAS BEEN BASED ON
FANTASY AND SCIENCE FICTION
AS WELL AS ILLUSTRATIONS
FOR CHILDREN'S BOOKS.

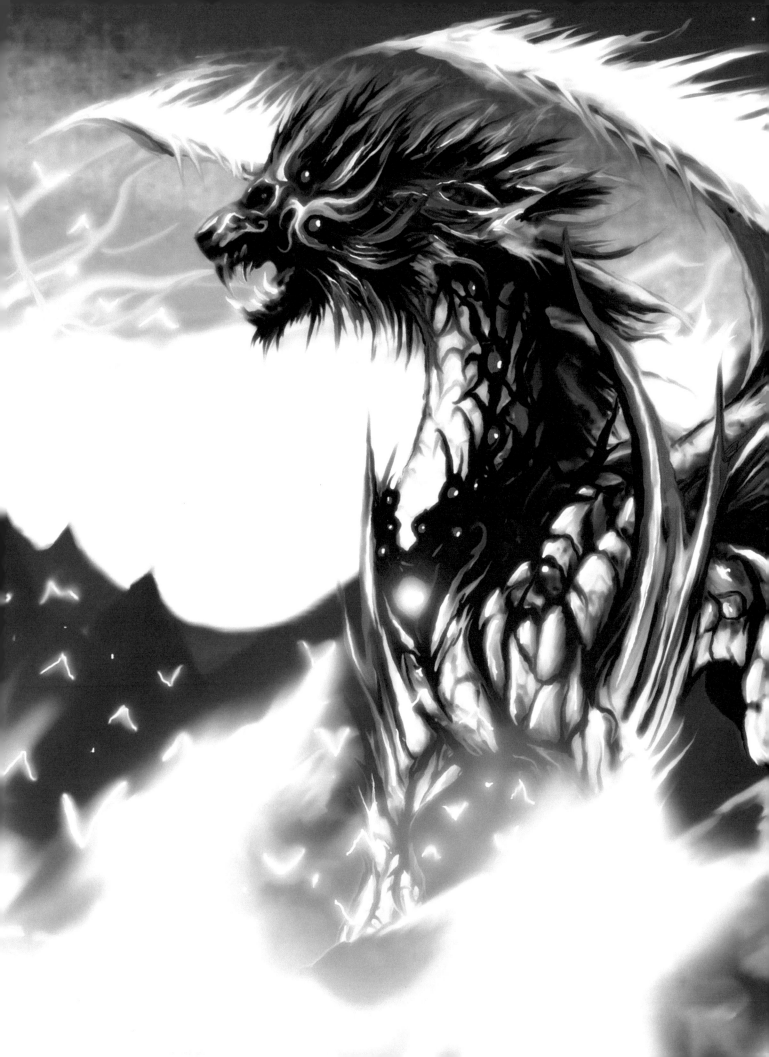

Printed in the United States
By Bookmasters